OVER THE MOUNTAINS

AN AERIAL VIEW OF GEOLOGY

Mount Whitney's granite peak in the Sierra Nevada of California is the highest point in the continental United States.

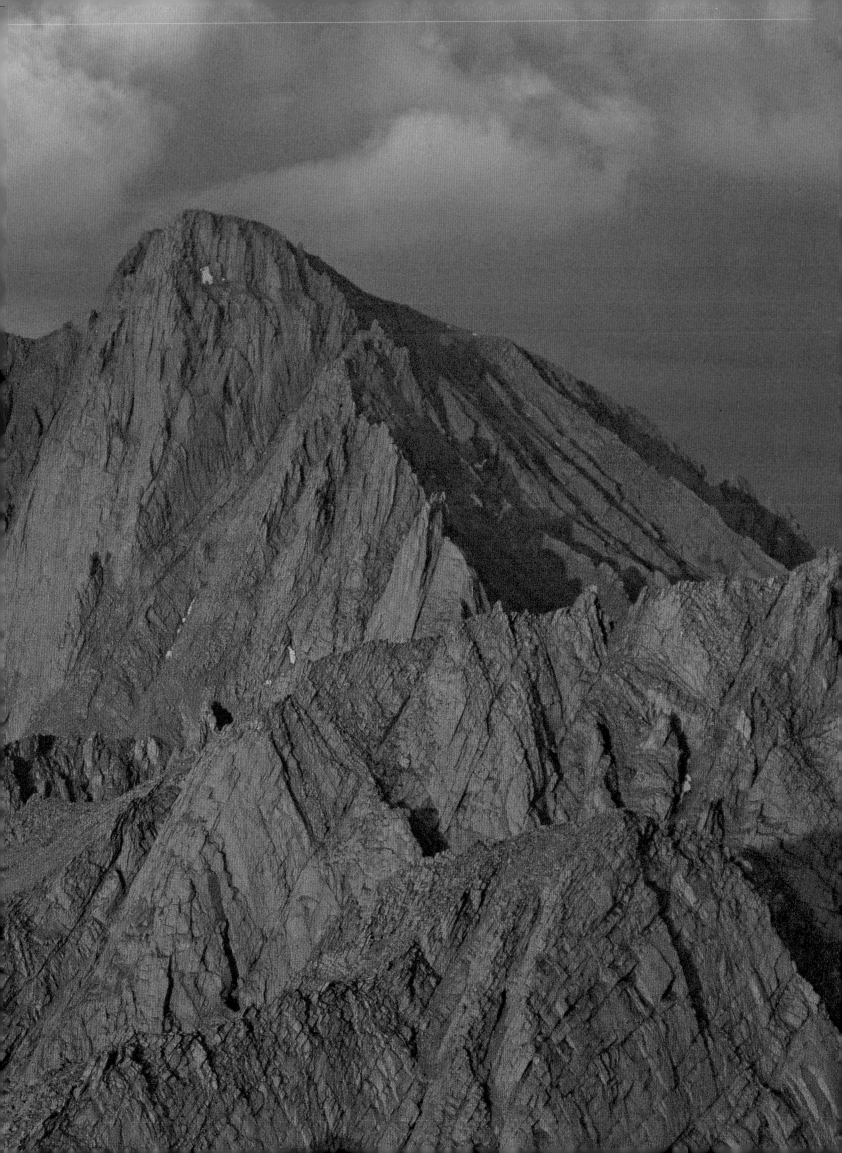

To John Shelton—who gave the world a new way of seeing itself forty years ago. Thanks for leading the way.

EDITORS: STUART WALDMAN AND ELIZABETH MANN
DESIGN & ILLUSTRATION: LESLEY EHLERS DESIGN

MAP PAGE 27: ANDRIES DE LETH. CARTE NOUVELLE DE LA MER DU SUD
THE LIONEL PINCUS AND PRINCESS FIRYAL MAP DIVISION, THE NEW YORK PUBLIC
LIBRARY, ASTOR, LENOX AND TILDEN FOUNDATIONS

MAP PAGE 42-43, 120-121
COPYRIGHT RAY STERNER, JOHNS HOPKINS UNIVERSITY APPLIED PHYSICS
LABORATORY, LICENSED BY NORTH STAR SCIENCE AND TECHNOLOGY, LLC

LIBRARY OF CONGRESS CATALOGING-IN-PUBLICATION DATA

Collier, Michael, 1950-
 Over the mountains : an aerial view of geology/ Michael Collier
 p. cm
Includes bibliographical references and index
ISBN 1-931414-18-1
1. Geology--North America--Aerial views. 2. Mountains--North America--Aerial views.
3. Aerial photography in geology. 1. Title
 QE71.C652007
 557--dc22

 2006047151

Printed in Spain

Mounts Ellsworth and Hillers are part of southeast Utah's Henry Mountains, the last range to be named within the United States.

OVER THE MOUNTAINS

AN AERIAL VIEW OF GEOLOGY

Michael Collier

Foreword by John S. Shelton

MIKAYA PRESS
NEW YORK

FOREWORD

In many ways, most of us already know something about mountains. We know where they are, what they look like, and what they offer when we want to camp, hike, ski, fish, or simply savor grand scenery. Geologists know that mountains provide some of Nature's grandest displays, but they are also inclined to ask other questions like: Why are mountains located where they are? What are they made of? When were they made? What determines their shapes? Answers to these questions require long hours of hard fieldwork by geologists, equipped to sample and identify rocks, collect fossils, and plot on maps the exact relationships between the rock types.

For centuries this fieldwork was done on foot and horseback, the geologists making maps as they went. Their reports, many of them now classics, were illustrated with careful drawings made on site by skilled artists.

Photography emerged as a tool used by field geologists during the mid 1800s, when United States government surveyors went west to explore routes for a transcontinental railroad. By the 1870s, photographers such as William Henry Jackson and Jack Hillers accompanied the great western expeditions of John Wesley Powell and others.

They lugged heavy, cumbersome equipment—large view cameras and glass plate negatives—into the nation's most remote corners. Yet some of the photographs are so good that more than a century later researchers have succeeded in matching them, down to the exact same boulder or shrub.

Fundamental differences exist between a sketch and a photograph. A drawing has passed through the eye and mind of the artist—it shows what he thought he saw. A photograph, on the other hand, documents what really was there and therefore can serve as a genuine scientific tool. Enhanced by an aerial perspective, a photograph can reveal geologic stories in a spectacular, unexcelled fashion.

I was simultaneously bitten by the flying and geology bugs in the late 1930s. It soon became apparent that each fascination would nourish the other. I loved the flying, a new freedom in three dimensions, the stuff of my dreams as a small boy. And I loved the airborne perspective over rocky desert hills that my brother and I had explored in a stripped-down Model T Ford. Other geologists steered me toward new photo targets, enriching a collection of aerial photographs that was incorporated into my textbook Geology Illustrated, *and into sets of slides for teachers.*

Browsing through Michael Collier's aerial photographs of mountains, I am struck by the rich variety in his sense of scale and orientation, along with his sensitivity to light, shadow, form, and texture. Certainly many of those shots were planned. As a professional photographer, Collier knows something about being in the right place at the right time. Yet undoubtedly he came upon other scenes unexpectedly and had to make quick decisions about position and camera setting, all the while maintaining control of his aircraft.

Collier's combination of skill and talents—writer, photographer, geologist, and pilot (let alone doctor, but that's another story)—is truly impressive. He is indeed master of both the medium and the message. That he loves doing what he does is revealed in the contagious enthusiasm sprinkled through the text that accompanies each photograph. Read on and enjoy!

John S. Shelton

CONTENTS

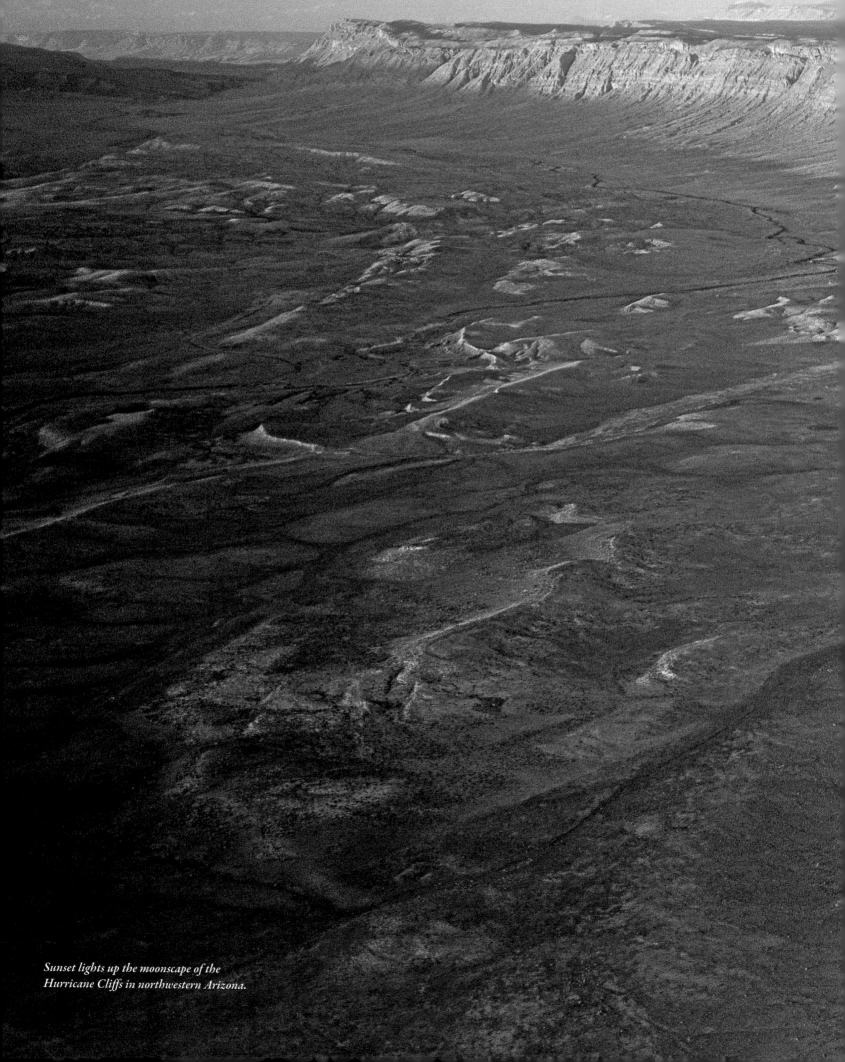

Sunset lights up the moonscape of the Hurricane Cliffs in northwestern Arizona.

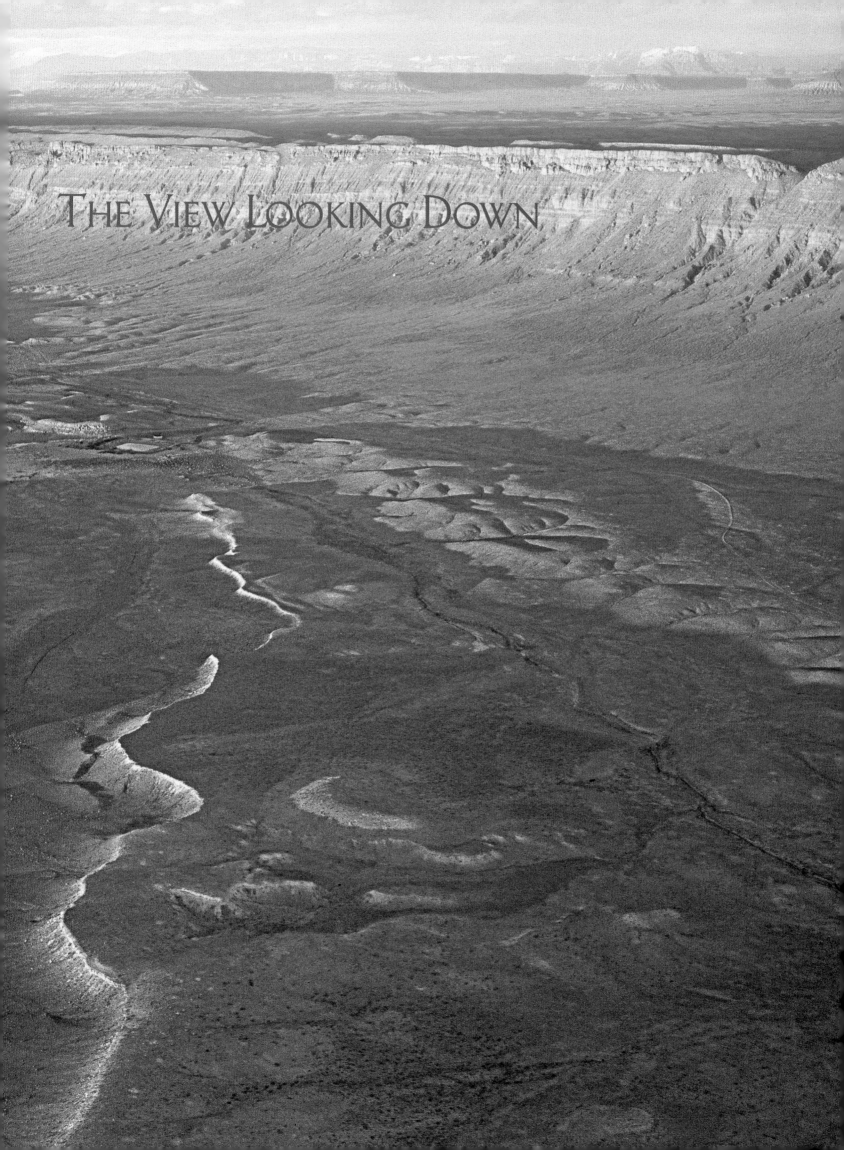

THE VIEW LOOKING DOWN

San Francisco Peaks north of Flagstaff, Arizona.

The San Francisco Peaks loom a mile above my home in northern Arizona. The peaks have silently witnessed a long parade of nearby human history—a Pueblo man praying to the spirit of mountain-dwelling Kachinas for rain a thousand years ago, an Irish immigrant building a railroad across the territory one hundred years ago, a Navajo woman in her blue velvet skirt herding sheep at the foot of these mountains she still calls *Dook'o'oslííd*. If only the San Francisco Peaks could share all that they have seen.

Mountains do have stories to tell. They could be about our human presence measured in centuries or a few millennia. Or they could describe the rich life of forests that have carpeted their slopes for millions of years. But the stories could also be about the earth itself, extending so far back into the past that their origins commingle with the very beginnings of time. The language of mountains is spoken with the throaty rumble of an erupting volcano; the words are whispered on winds that slowly abrade ridges of ancient granite. To hear these stories, we have to learn a new language called geology, one spoken by rocks and interpreted by science. We have to look at a landscape and learn to read its actions and antecedents.

The stories all start with a few basic questions: Why are there mountains? When were they made? Are some being created right now? What are they made of? Why are some mountains steep and peaked, while others are broad and rounded? Why are mountains bunched into batches or clustered into chains, present in some places and not in others? The answers to these questions reveal many of the earth's innermost mysteries.

Mountain ranges offer clear and compelling glimpses into the origin of North America. The spiky Bugaboo Range of British Columbia and the hoary Sierra Madre of Mexico both reflect the crumpling of this continent. The soft rounded slopes of Nevada's volcanic cinder cones and the angular ridges of its Basin and Range Province tell of times when the continent was being stretched apart. There are so many different types of mountains—the chaotic Pacific Coast Range and the stately Rocky Mountains, the venerable Great Smoky Mountains of Tennessee and the worn-down Ouachitas in Arkansas. All of these mountains tell tales that rise through time from deep within the earth.

Geology concerns itself with features that range from microscopic crystals to satellite views of the entire planet. It's not inconceivable that geologists would discuss subatomic particle physics one day and cosmology of the solar system the next. But usually these scientists just talk about rocks: their mineral constituents, the layers in which rocks occur, and the deformation of these layers. Then they try to put this knowledge into a larger context: What do these rocks tell us about the history of our planet?

The earth is so large and we're so small. How can you keep both minerals and mountains in perspective? You could spend a lifetime hiking and exploring, and only just begin to understand how mountains fit into the rest of the world. On the ground, like mites on an elephant, you don't know if you're sitting on the elephant's tooth or its toenail. But a view from the sky adds another dimension. Rise above and you can see the earth from trunk to tail.

From the air, the fabric of a landscape becomes visible—mountains arching here, valleys plummeting there; volcanoes erupting, lakes drowning, landslides collapsing. With an aerial panorama, we see how large features are quilted together: Granite peaks give way to graceful sedimentary slopes, canyons are seamlessly stitched into wider valleys. A sense of time is the geologist's best hand lens, the open window of a small plane his best perch.

I learned to fly in 1975 while studying geology, five years after beginning a career in photography. The three disciplines nested well, each exciting and challenging, each complementing the other. My instructor, Chris Condit, was also a geologist. We spent weeks on end wandering the West,

marveling at how clearly we could discern classic features we'd seen in textbooks—Mount St. Helens, the San Andreas Fault, the sublime Sierra Nevada. Along the way, while earning degrees in structural geology, I stumbled into being a pilot.

Thirty years later, after five thousand hours aloft, I've never regretted the paths I followed. With this book, I'd like to share that aerial perspective on mountains. I'd like to show geologic features of America's high country that illuminate the theories by which scientists have come to understand our continent. Mostly I'd like to impart a sense of wonder, a tangible sense of the earth, that springs from an intimate knowledge of the land.

I once flew north toward Denali (or Mount McKinley as it's still officially known). Departing Anchorage under a low ceiling, I was forced to skim the treetops. Approaching Cantwell an hour later, the clouds parted and the Alaska Range reared up, hooves raking the sky. My plane, fifty years old, knows how to do one thing very well—fly, and then fly some more. Forest and foothills fell behind as we climbed. . . six thousand feet, nine, twelve, fifteen thousand. At fifteen and a half, the altimeter barely advanced. Clouds like prayer flags streamed over Mt. Foraker. Denali—The Great One, the roof of North America—was still a mile above. I was awestruck by this other universe—this soaring white world where the ridges reveal little rock and a lot of snow. I could fly forever in this sky full of mountains.

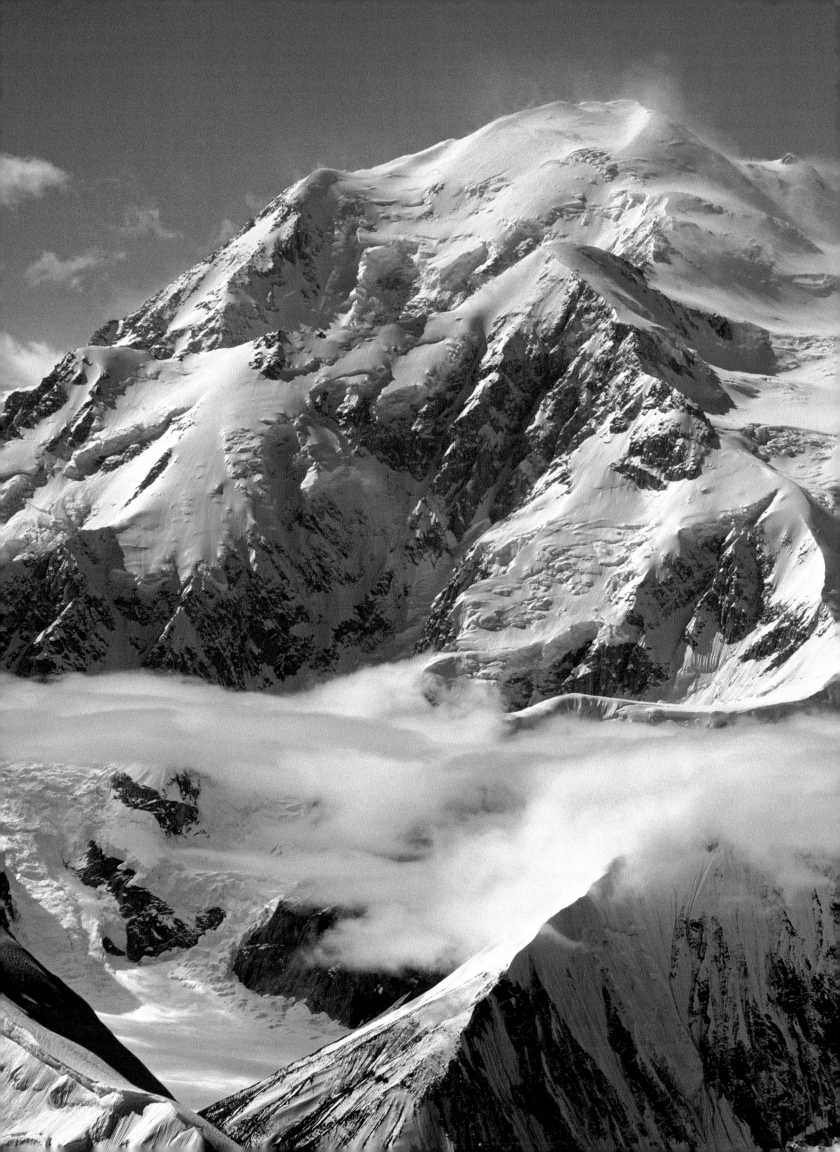

At 20,320 feet, Denali is the highest peak in North America, dominating the Alaska Range. Squadrons of glaciers cling to its wrinkles and crags, carrying ice and rock to the valleys below.

North Cascades National Park, Washington.

MOUNTAINS FROM THE GROUND UP

Rocks

We all think we know what we mean by mountains, so it's surprising that folks still disagree about what constitutes a mountain. Depending on which dictionary you happen to use, a mountain might be "a steep elevation with a restricted summit projecting at least 1,000 feet above the surrounding land surface." On the other hand, it may be "a high landmass with peaks or ridges." Or perhaps a mountain is nothing more than "any conspicuous hill in an area of low relief." At any rate, a mountain should not have too broad a top, lest it become just another flat plateau.

Geologists look past exterior shapes and see the rocks inside. Rocks come in three basic flavors: vanilla, strawberry, and chocolate. Of course, geologists give them scientific names: sedimentary, igneous, metamorphic. By whatever name, there are just three flavors.

Sediments are loose particles—sand grains, mud, boulders, you name it—that are transported by wind or water. Rivers carry silt and dump it into the ocean. Wind strips sand from a shoreline and then drops the grains in dunes a short distance behind the coast. Ocean water carries dissolved lime and, when calcium concentrations rise, dump lime on the sea floor. These sediments are first deposited willy-nilly in loose piles with some space between the grains. Mineral-laced water can filter through the spaces, coating the grains with calcium, silica, or other fine films that cement the particles together. As more sediments are piled on, the overlying weight compresses the grains, which are now cemented into coherent layers of sedimentary rocks—like shale composed of silt, sandstone composed of sand, and limestone composed of particles of lime.

A second, fiery type of rock is called igneous. The earth's interior is hot enough that some portions are liquid, not solid. Molten rock, called magma, is relatively light and can flow toward the surface. Magma is a rich brew of oxygen, silica, aluminum, iron, calcium and other elements, which remain liquid as long as they are held at a sufficiently high temperature.

At Capitol Reef National Park in Utah, uplift followed by erosion has sculpted sedimentary rocks, exposing the tan Navajo Sandstone beneath thin red layers of the Carmel Formation. The Navajo preserves 200-million-year-old windblown sand dunes—seen here as an interweaving of fine diagonal lines in the lighter-colored walls.

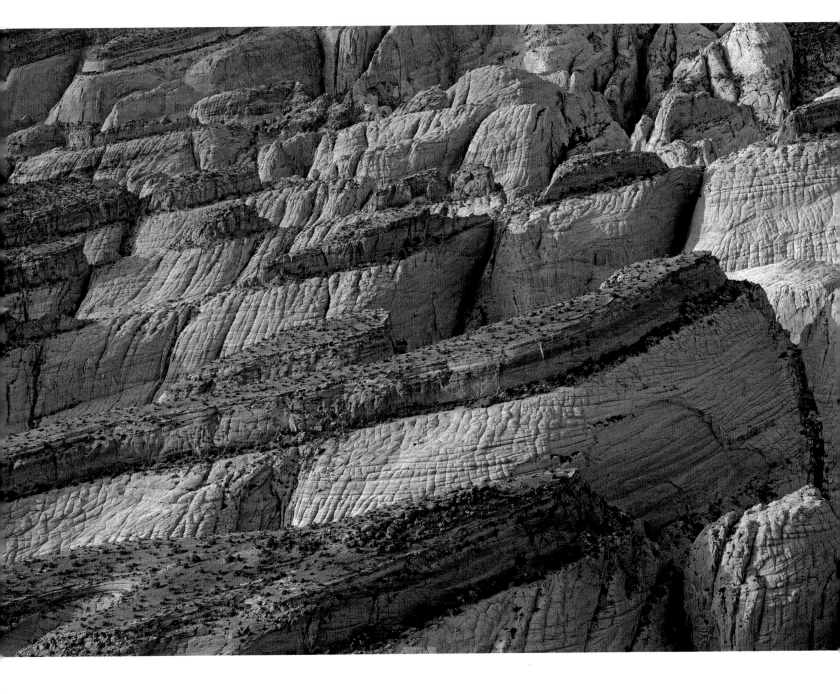

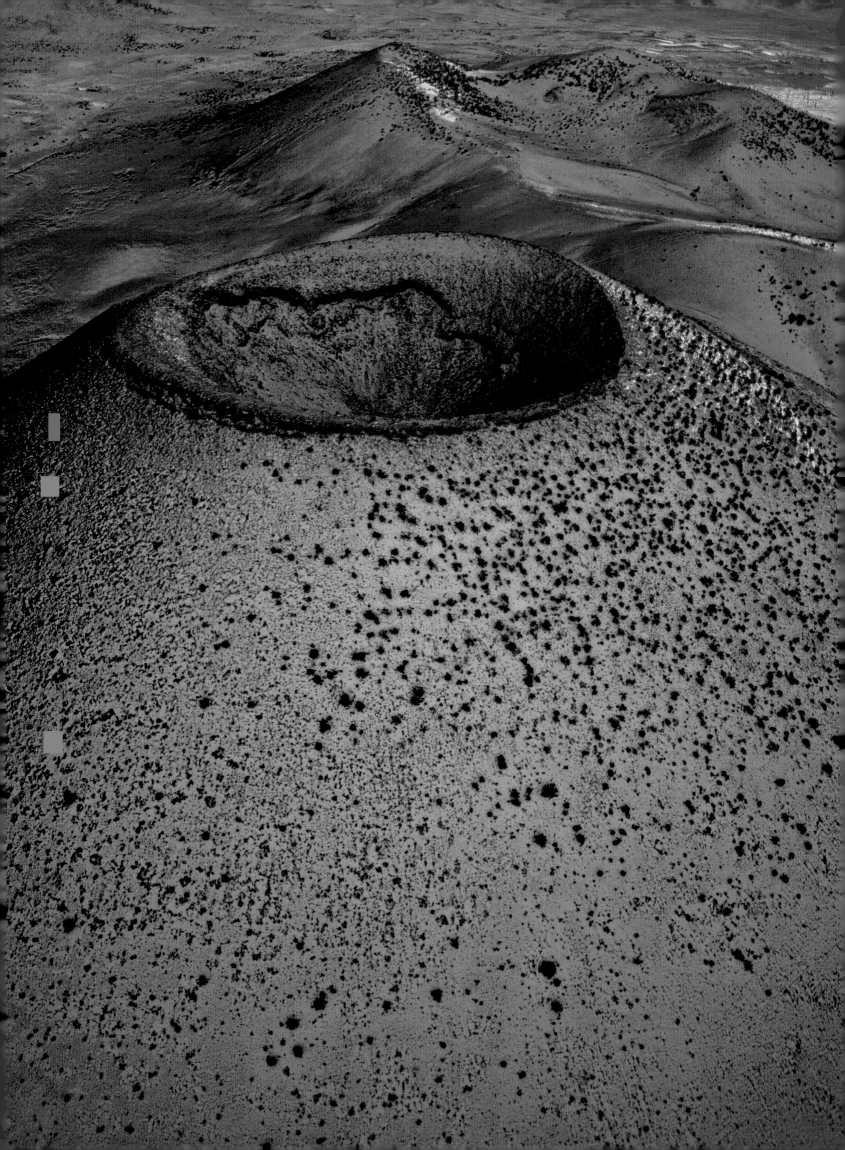

As temperatures fall below 2,400° Fahrenheit, individual elements begin to cling to each other, literally "freezing" into crystalline minerals. Magma could remain underground and slowly freeze into large-grained minerals like quartz, feldspar, and mica to form granite or rhyolite. Or it might rise to the surface, erupting as a volcano to produce fine-grained rocks like basalt or andesite. Any rock—above ground or below—that crystallizes from magma is called igneous.

The final category is metamorphic. Meta means "change," and morph means "form." When a rock is sufficiently heated and squeezed, it begins to change form. Atom by atom, crystals become unstable and are transformed into other minerals better adapted to withstand the new conditions of heat and pressure. The resulting mineral assemblage is then called a metamorphic rock—siltstone has become schist, sandstone is now quartzite, and limestone has turned into marble. At no point did the rock melt, because then it would have become igneous instead.

That's all—sedimentary, igneous, metamorphic. The sedimentary rocks don't have to be white, but they can be. The igneous rocks were sure red at one point in their molten past. And metamorphic rocks are often chocolate-colored. There you have it: vanilla, strawberry, and chocolate. As any connoisseur knows, however, distinctions between flavors can blur. Is chocolate-chip ice cream vanilla or chocolate? Over really long periods of time, rocks might mutate from one category to another. Sedimentary rocks can be heated and squeezed to gradually transform into metamorphic rocks. Igneous rocks can be worn into tiny sand grains and be redeposited to become sedimentary rocks. Metamorphic rocks might be heated up enough that they finally do melt and then recrystallize as igneous rocks.

James Hutton, an eighteenth-century geologist, knew that fragments of metamorphic rock had been eroded and then redeposited as sediment along the coastline of Scotland; he understood that volcanic magma had frozen into basalt. Hutton may not have known how rocks change, but he appreciated that, over long periods of time, they do change. He called this revolving arrangement the "rock cycle."

S.P. Crater in northern Arizona is a volcanic cinder cone, an igneous landform that displays an unblemished symmetry because it is young—merely 70,000 years old. The crater started life when gaseous molten rock spewed fine ash and cinders skyward. Later in the eruption, after much of the gas had escaped, magma oozed rather than frothed, thus forming the erosion-resistant "spatter rim" of welded cinders that now preserves the cone's elegant shape.

The Teton Range within Wyoming's Grand Teton National Park is built upon blocks of dark metamorphic gneiss that appear here to be foundering in a pool of light-colored granite. Two and a half billion years ago, the Mount Owen Granite—an igneous rock—was injected into and around the much older gneiss. This intrusion took place deep within the earth, long before today's mountains were uplifted and subsequently exposed by erosion.

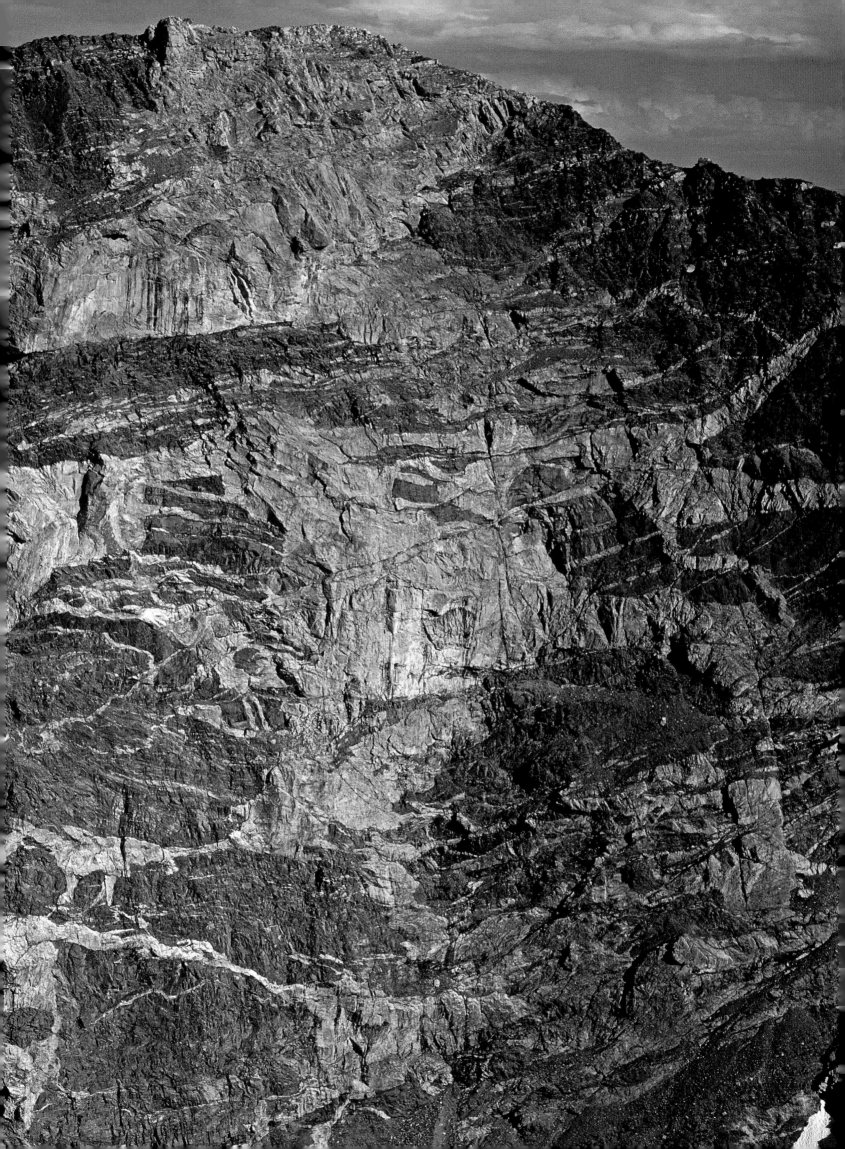

Plate Tectonics

Mountain ranges do not occur randomly. From the window of a cross-country jet, you can see broad patterns in the distribution of mountains. Climbing westbound out of New York, you first encounter the Adirondacks and the subdued spine of the Appalachian Mountains, then the yawning Great Plains, before skimming over the Continental Divide in Colorado. Do you see how the massive Rockies are aligned north-south? Continuing west, the flight crosses innumerable parallel mountains of Utah and Nevada. Finally you look down on the southern curl of the Sierra Nevada as the plane descends into Los Angeles. In four hours you have learned some fundamental lessons of geology: that mountains are likely to come in ranges; that each range is oriented in a particular direction, often north-south in North America; and that the ranges are clustered into a relatively small part of the continent.

So what caused mountains to be oriented like this? Why are there more mountains in Colorado than Kansas? For centuries, scientists grappled with these questions without providing very satisfactory answers. In the sixteenth century, a Dutch cartographer named Abraham Ortelius observed that Africa's west coast and South America's east coast, without the intervening Atlantic Ocean, would nicely nestle together. Could the continents have been joined, then somehow split apart? Three hundred years later, Alfred Wegener would elucidate an all-but-overwhelming body of evidence for the drifting of continents.

Wegener was a German scientist who in 1912 described fossils of a seed-bearing fern known as *Glossopteris,* collected across parts of Africa, India, South America, and Australia. The same fossil was also spotted in rocks in Antarctica. Since identical forms of this plant were unlikely to have evolved simultaneously on continents widely separated by oceans, Wegener hypothesized that the continents must have been connected at some point in the past. Wegener reported glacial scars in India and Saharan Africa where no right-minded glacier would now dream of growing, further evidence that

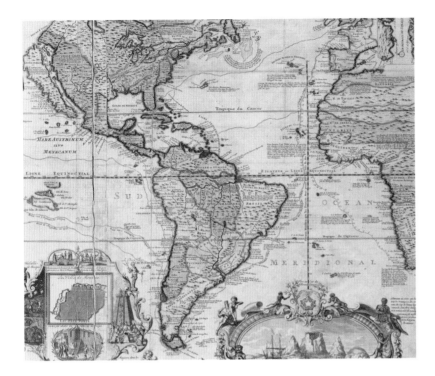

the once-connected continents must have drifted away from their earlier position near the South Pole toward the equator.

Wegener proposed his theory of continental drift to a skeptical scientific world, but a critical piece of the theory was missing. He was never able to explain how entire land masses could plow through the ocean floors. He died during an arduous expedition to Greenland in 1930, Wegener was buried in the ice by a search party the following year. He died without seeing his theory fully accepted.

In the early twentieth century, earth scientists divided into two camps—"drifters" and "anti-drifters"—and would squabble about continental drift for the next fifty years. But some ideas are just too powerful to be held back for long. During World War II, Princeton geologist Harry Hess found evidence at the bottom of oceans that supported continental drift theory. Using U.S. Navy sonar, Hess crudely mapped out underwater mountain ranges that ran down the middle of many of the world's oceans. By the 1960s, scientists could show that seafloor rocks are created where the ocean floor is pulled apart and magma emerges at these mid-ocean ridges called spreading centers. As more magma rises, the newly-formed ocean floor is carried away from the ridge, to be replaced by even younger rocks.

Scientists continued to grapple with the ideas of continental drift throughout the mid-twentieth century. But in 1963 any remaining doubts were dispelled when geophysicists Fred Vine and Drummond Matthews tracked movement of the seafloor by examining magnetic stripes preserved in its rocks. They proved that, over the millennia, the seafloor had moved steadily away from spreading centers. Wegener's missing piece could now be filled in. Continents don't plow through an ocean floor; they ride with it.

With an understanding of seafloor spreading, Alfred Wegener's original idea of continental drift had become the modern theory of plate tectonics. Using this theory, geologists today can imagine oceans splitting down the middle and entire continents swirling around the earth's surface like leaves on a pond. They understand that continents collide and mountains rise because of magmatic movement. The theory of plate tectonics shows us that there are mountains on earth because the earth is alive.

Geologists are endowed with a sort of X-ray vision called geophysics. By analyzing the reverberations of earthquakes, they can map out the interior of the earth. The planet, they have discovered, is comprised of three layers. A mushy middle zone called the mantle surrounds a dense central core. The core and mantle are covered in turn by a thin crust on the surface. This outer shell comes in two styles: thin oceanic crust that is only about four miles thick, and continental crust with an average thickness of twenty miles.

Temperatures within the core approach 9,000° Fahrenheit because the earth retains heat from the time of its formation four and a half billion years ago, and because it generates new heat from the nuclear decay of minerals like uranium. The iron-rich core is extremely hot and would be

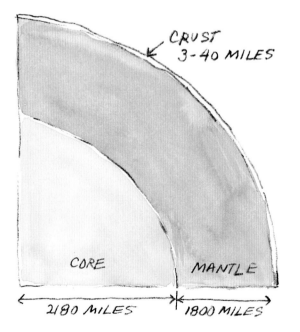

liquid except that it is squeezed by tremendous gravitational pressures that force it to remain solid.

The overlying mantle, hot but under less pressure than the core, exists in a state somewhere between a thick liquid and a spongy solid. Eighty percent of the earth's mass is contained in the mantle. Vast streams of molten rock slowly move through the mantle like currents in a viscous pot of boiling soup. These currents are the driving force that propels plates around the surface of the world.

The earth's crust—both oceanic and continental—literally floats on top of the mantle. Ocean floors may be thin but are denser than continents, so they sink a little lower into the mantle while the continents ride a little higher. As a result, ocean floors tend to lie below sea level, while continental crust tends to float on average about 2,500 feet above sea level.

In the modern theory of plate tectonics, the word tectonics simply means "processes that crimp and crease the earth's crust." Tectonics may sound scary, but it's actually the word plate that gets my attention. According to plate tectonics theory, the earth's surface is roughly divided into seven huge plates. Each plate can contain either thick continental or thin oceanic crust—or both. Geologically speaking, the plates zoom around the surface of the earth like irresponsible bumper cars. Any two plates can interact in one of three ways: They can separate, collide, or just scrape past one another. These interactions create mountain ranges.

When plates separate at a spreading center, magma from the underlying mantle wells up to fill the resulting void. Motion within the mantle is organized into pairs of gyres, each rising toward a common spreading center. The gyres help distribute heat away from the earth's core, releasing it as hot molten magma that cools when it reaches the sea above. New rocks are formed as magma freezes against the retreating edges of the overlying oceanic crust. As the gyres rotate, they carry the ocean plates on their backs away from the spreading center. Most spreading centers are on the ocean floor, hidden from view. They form a continuous seam of underwater ridges that encircle the globe like stitches on a baseball. These spreading centers zig-zag along a total length of 36,000 miles, easily the longest mountain chain on earth.

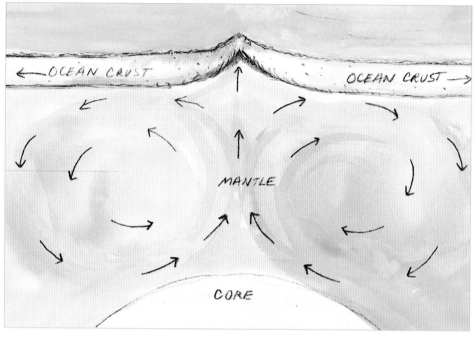

SPREADING CENTER

An ocean plate can be carried thousands of miles from a spreading center. If it collides with a continental plate along the way, the denser oceanic crust is likely to be thrust under the more buoyant continental crust. This process, called subduction, is happening right now beneath southern Alaska. As subducting oceanic crust descends, it is warmed by the earth's interior heat and melts back into the mantle.

During the time it traveled across the surface of the earth, the oceanic plate would have gradually accumulated a veneer of sediment. Encountering a subduction zone, some sedimentary rocks will be scraped from the descending ocean crust onto the nose of the opposing continent. This process is largely responsible for the ongoing creation of the Olympic and Cascade Ranges in Washington. But in other places sediments will be dragged deeper into the mantle. Temperatures rise as subduction proceeds, and these water-laden sediments tend to melt early in the process. Once molten, they rise again to form igneous intrusions within the overlying continent or to erupt as volcanoes at the surface.

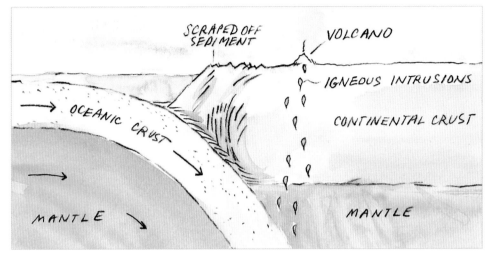

OCEAN CRUST-CONTINENT COLLISION

On the other hand, when a head-on collision occurs between two pieces of equally buoyant continental crust, neither is willing to sink beneath the other. The leading edges of these rigid plates crumple like tin foil, forming mountains. Often the colliding continents will splinter along great fractures called thrust faults, which can penetrate hundreds of miles back into the opposing blocks of crust. India (a continent) first banged into Asia (also a continent) about fifty million years ago. This ongoing event is recorded by the rise of the Himalayas.

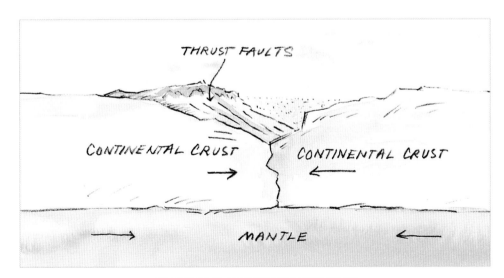

CONTINENT-CONTINENT COLLISION

Finally, it is possible for two plates to just slide horizontally past one another, sideswiping rather than colliding or separating. When rocks move relative to one another, the surface between them is called a fault. California's famous San Andreas Fault is a world-class example of this type of side-by-side plate interaction.

SIDE-BY-SIDE MOTION

The San Andreas Fault has ripped through California's Carrizo Plain. The hills to the left are the westernmost edge of the North American Plate; the smooth plain to the right is the eastern edge of the Pacific Plate. Dry washes are offset by motion along the fault, so that washbeds on the right are carried with the Pacific Plate toward the bottom of the picture. Because the plates glide horizontally past each other, plate movement in this region forms only small hills called shutter ridges rather than great mountains.

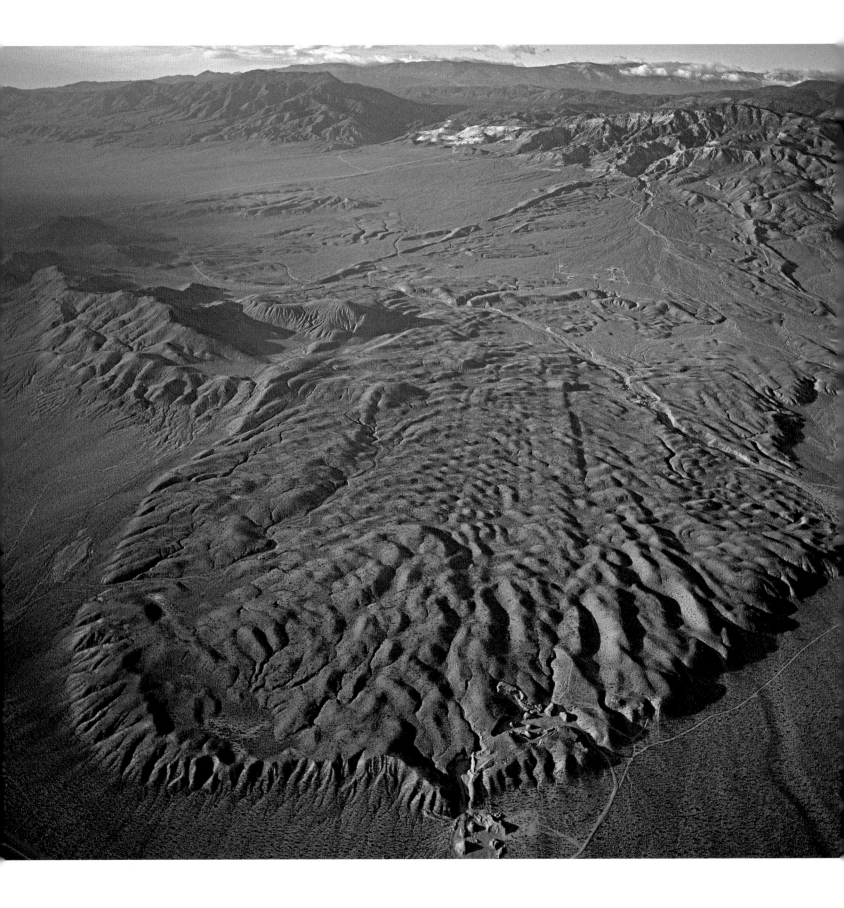

Erosion

A mountain has only just begun its existence when plate tectonics first thrusts it up from the earth's interior. There is much left to be done before it looks like any mountain we might recognize. Erosion is the collection of processes by which materials are broken loose and carried away by agents like water and wind, dissecting the original upthrust rock into a myriad of peaks, ridges, valleys, and canyons.

Michelangelo would hardly have been content to leave a raw block of marble parked in his living room. Instead, he had to carve the stone, releasing David from within. Erosion is the grand sculptor responsible for the sweep and curve of exalted mountain landscapes. We have seen how plate tectonics creates mountains, but other processes like erosion are simultaneously wearing them down. One of geology's most difficult (and important) concepts is that multiple processes often operate upon a landscape at the same time. Rocks can be going up even as they are being torn down.

Earth's atmosphere is the greatest determinant of how mountains are shaped, shaved, and polished. Wind, rain, ice, and snow all seem soft compared to rock, but with time on their side, atmospheric agents will inevitably attack even the most resistant gneiss or granite. A mountain range actually invites this destruction by generating its own weather. Peaks get in the way of clouds, damming the flow of air that carries moisture downwind. The harsh mountaintop environment—often wet, almost always windy, repeatedly freezing and thawing—leads to high rates of rock destruction, a process known as weathering.

Peaks are chewed up and spit out nearly as fast as the earth raises them. Once a rock crumbles, it's not long before the fragments heed the call of gravity and head downhill. Landslides are a dramatic mechanism by which mountains shed their skirts of debris toward the valleys below. Another mechanism of movement—the rock glacier—is more subtle. Snow and rainwater readily percolate into the spaces between rocks perched on a mountain slope, thus lubricating loose fragments until they

The massive Blackhawk Landslide is a two-mile-wide sheet of crumbled limestone. Seventeen thousand years ago, it literally leapt out of the San Bernardino Mountains in southern California, flying five miles on a carpet of compressed air in perhaps as little as eighty seconds.

begin to ooze downhill.

True glaciers—composed of ice, not rock—are the most formidable earth-moving machines ever to prowl the face of the planet. A glacier's gliding ice plucks fragments directly from a mountain's bedrock surface and also incorporates loose rocks that fall from cliffs onto its icy surface. Alaska's Margerie Glacier is a conveyor belt that constantly chews up the Fairweather Range, hauling it piece by piece to tidewater, annually lowering the surface of the basin through which it slides by two and a half inches. Glaciated mountains like the Fairweathers are carved into a unique topography: U-shaped canyons beveled by valley glaciers, bowls called cirques inaccessibly perched high on a cliff, and deep alpine lakes called tarns gouged out by ice.

Glaciers and landslides offer wild rides for the products of weathering, but streams and rivers more steadily accomplish the yeoman's work of earth's erosion. High in the mountains, water may linger awhile in lakes, but soon enough streams will begin their boisterous descent to sea level. Rushing water carves depressions that gradually grow into canyons. As canyon walls widen, erosion can whittle the shoulder of a mountain into a ridgeline. Over time, the inexorable effects of water transform narrow canyons into broad valleys as the mountains themselves are worn down to nothing.

Water is particularly effective when it encounters zones of weakness. Water will always try to erode through a softer rather than harder rock. Soft sedimentary layers like shale quickly wear away when attacked by running water; the resulting slopes are often pleasantly rounded. Streams carve more easily into faults and loose zones of rubble where fractures have already weakened the rock.

Gravity-driven processes of erosion begin to run out of steam as they work their way downhill. A steep mountain creek is much more turbulent—and able to carry larger sedimentary particles—than a stream with a more shallow gradient on a valley floor. Sand, gravel, and cobbles brought down from a mountain by storm water suddenly drop out of suspension as the flood loses speed at the foot of the slope. As a result, many mountains in arid regions wear matronly aprons of sediment called bajadas. In places

Rain erodes ridges within Denali National Park, washing sediment into the Toklat River. The river's channel is braided, a pattern that indicates copious sand and gravel.

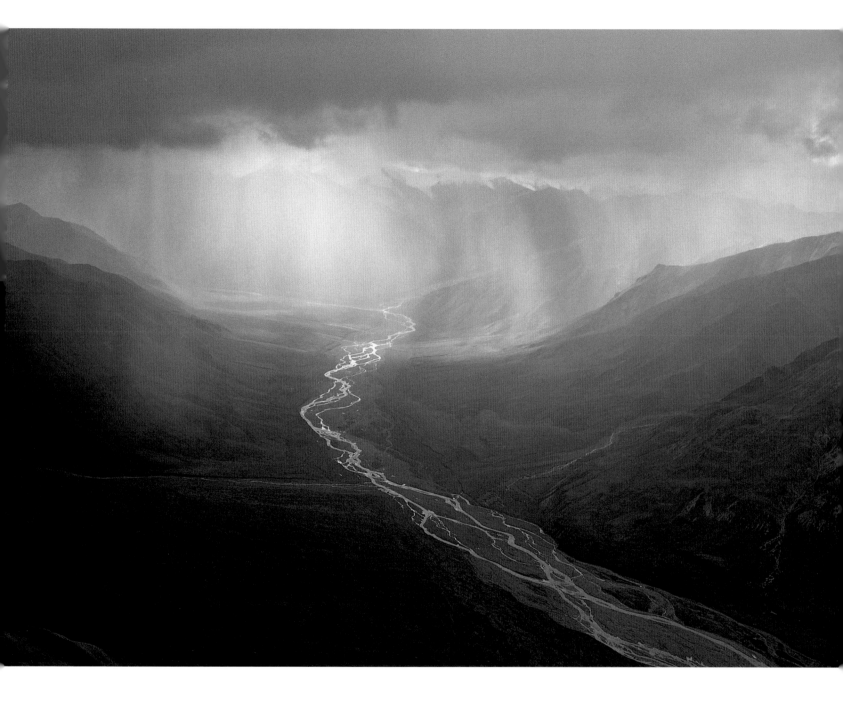

where mountain weathering and erosion are brisk, some peaks barely hold their heads above these lapping waves of coarse sediment.

Mountains may be massive and seem immovable, but in a geologic sense they are ephemeral, existing in a delicate balance between the powers of tectonic creation and erosive destruction.

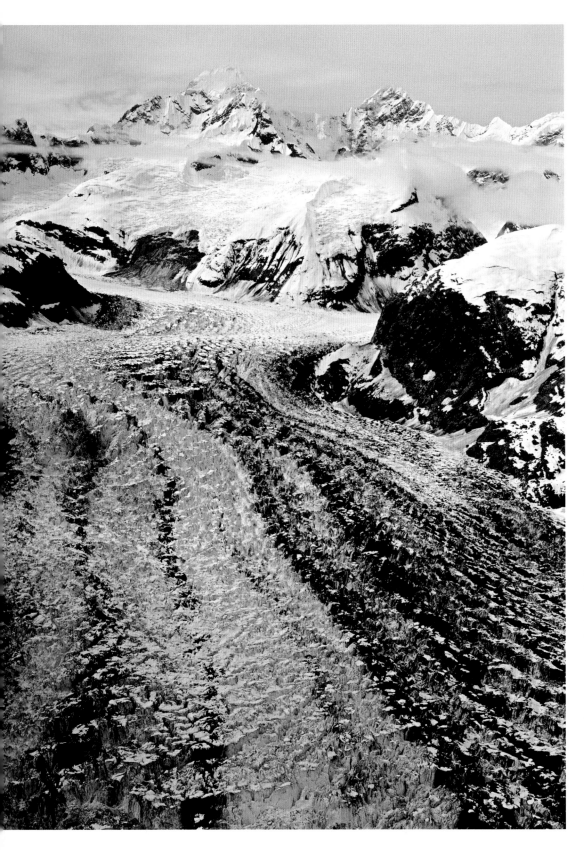

Left: Johns Hopkins Glacier slides steadily down from the Fairweather Range within Glacier Bay National Park in Alaska. The dark lines, called medial moraines, are streamers of rock plucked from the walls upstream and incorporated into this river of ice.

Right: An apron of loose rocks covers the desert north of Shoshone, California, forming a bajada that is dissected by dry stream beds. Eagle Mountain is the tilted block of half-billion-year-old layers in the upper center of the picture, a foundering range that now barely rises above the bajada's waves of sediment.

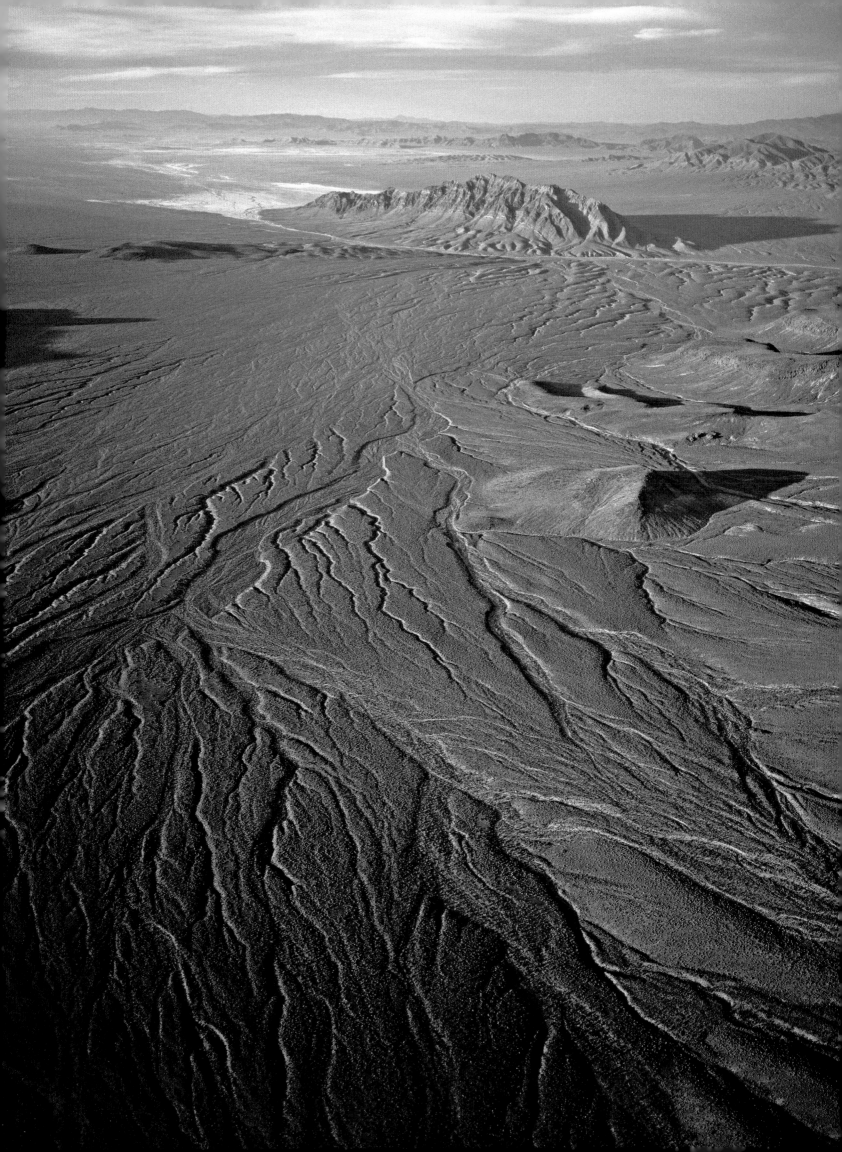

San Juan and Elk Mountains, west-central Colorado.

THE MOUNTAINS OF AMERICA

Scientists find it useful to divide the United States into major regions called provinces, each defined by the general similarity of its rocks, landscape, and geologic history. Mountains within the Appalachian Highlands Province were formed hundreds of millions of years ago when first Europe and then Africa plowed into North America. The Rocky Mountain Province was squeezed up more recently, about 70 million years ago, when North America was assaulted by an oceanic plate steaming in from the west. The crust beneath Nevada's Basin and Range Province is surprisingly thin because it is being pulled apart like taffy, creating a landscape dominated by parallel mountains that look like unsightly stretch marks. Each province has a unique geologic history which has produced regions of distinctive character throughout the continent.

U.S. GEOLOGICAL PROVINCES

1. *Pacific*
2. *Columbia Plateau*
3. *Basin and Range*
4. *Colorado Plateau*
5. *Rocky Mountain*
6. *Interior Plains*
7. *Laurentian Upland*
8. *Ouachita-Ozark Highlands*
9. *Atlantic Plain*
10. *Appalachian Highlands*

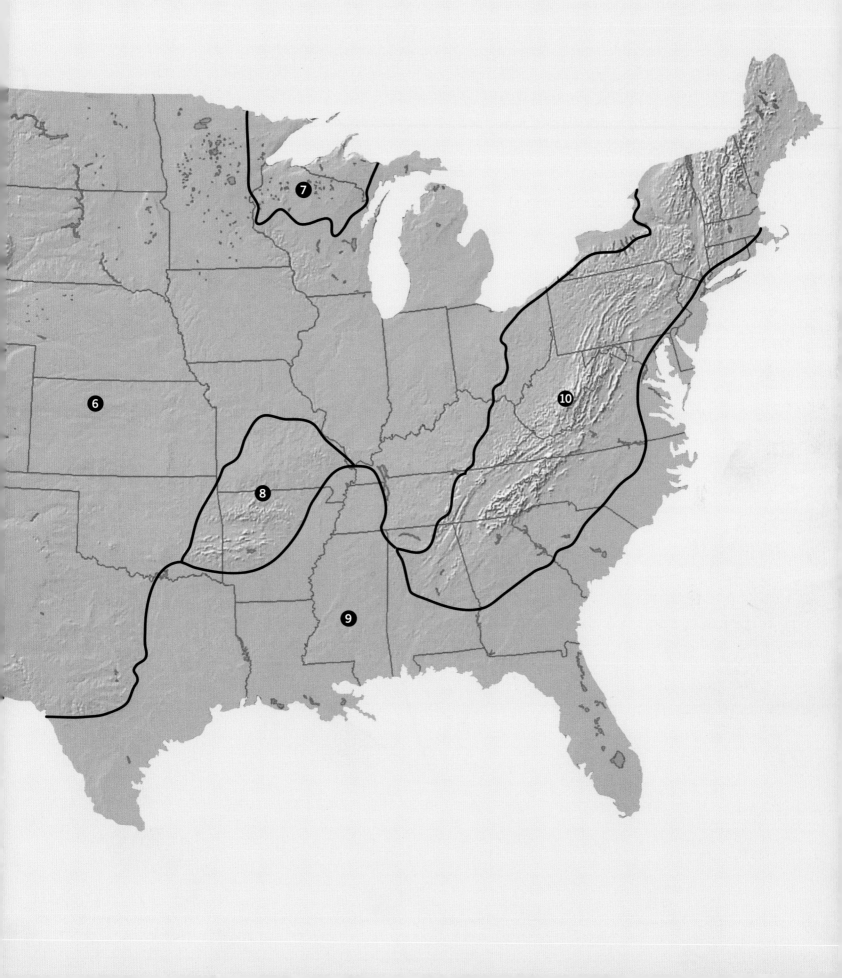

The Appalachian Highlands Province provides North America's best example of continents colliding. The Appalachian Mountains were formed during three separate pulses of west-directed compression as continents repeatedly collided with the eastern edge of North America beginning about 450 million years ago. The final push began 300 million years ago, a time when all of the world's continents were organizing themselves into a single giant landmass called Pangaea. When North America collided with Europe and Africa, the east coast of the United States was heaped into the mountain range now known as the Appalachians. The tectonic fireworks continued for 70 million years, producing a seamless mountain range six thousand miles long that stretched from Greenland through Georgia to Morocco. Since then, the range has been fragmented as continents reversed directions, spreading apart to form the Atlantic Ocean. Now those once-connected mountains are scattered from Scotland to Scranton, from Marrakech to Maine.

Right: Clinch Mountain in Tennessee lies within the Valley and Ridge District of the Appalachian Highlands Province. The province is made up of sinuous ridges like Clinch Mountain that were created when Africa collided with North America.

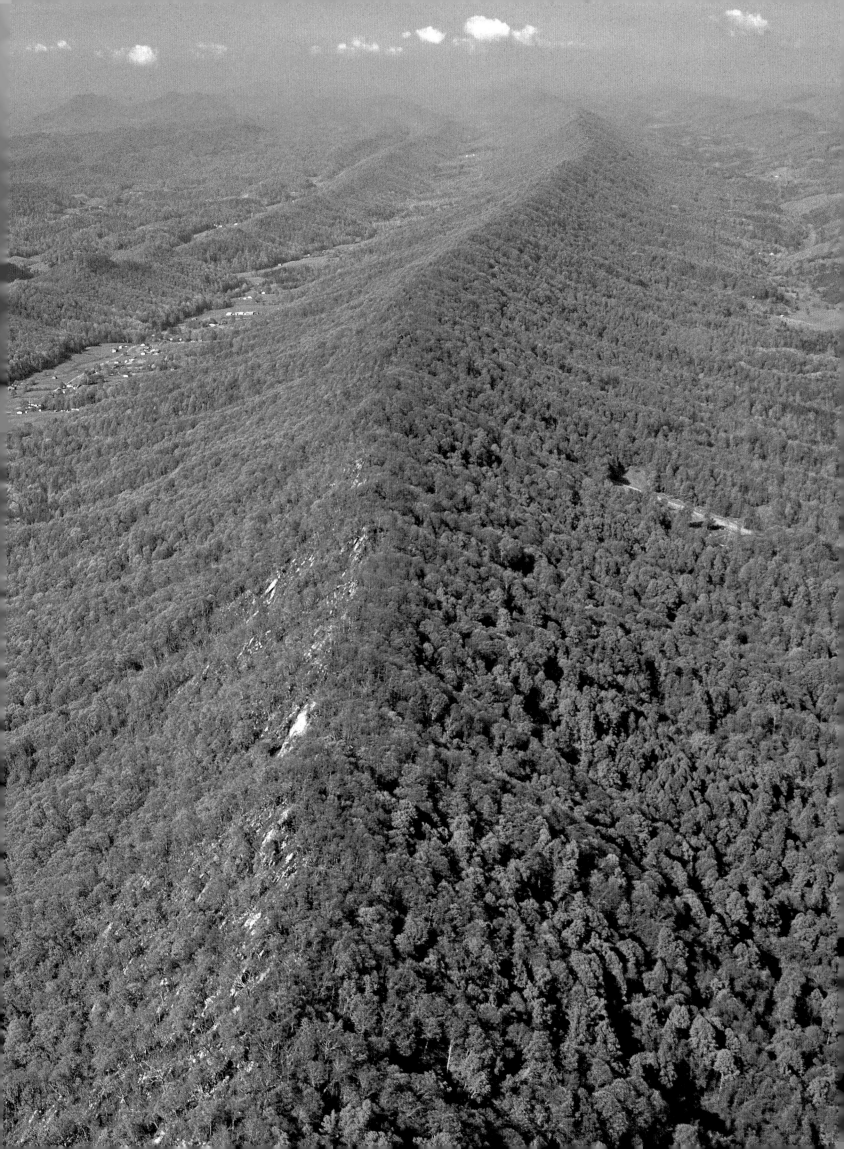

Foothills of the Appalachian Mountains near Chattanooga, Tennessee, are aligned northeast-southwest in parallel rows. Compression crumpled the upper layers of earth's crust into these ridges. This wrinkled-rug pattern lay buried within the earth until it was exposed by erosion.

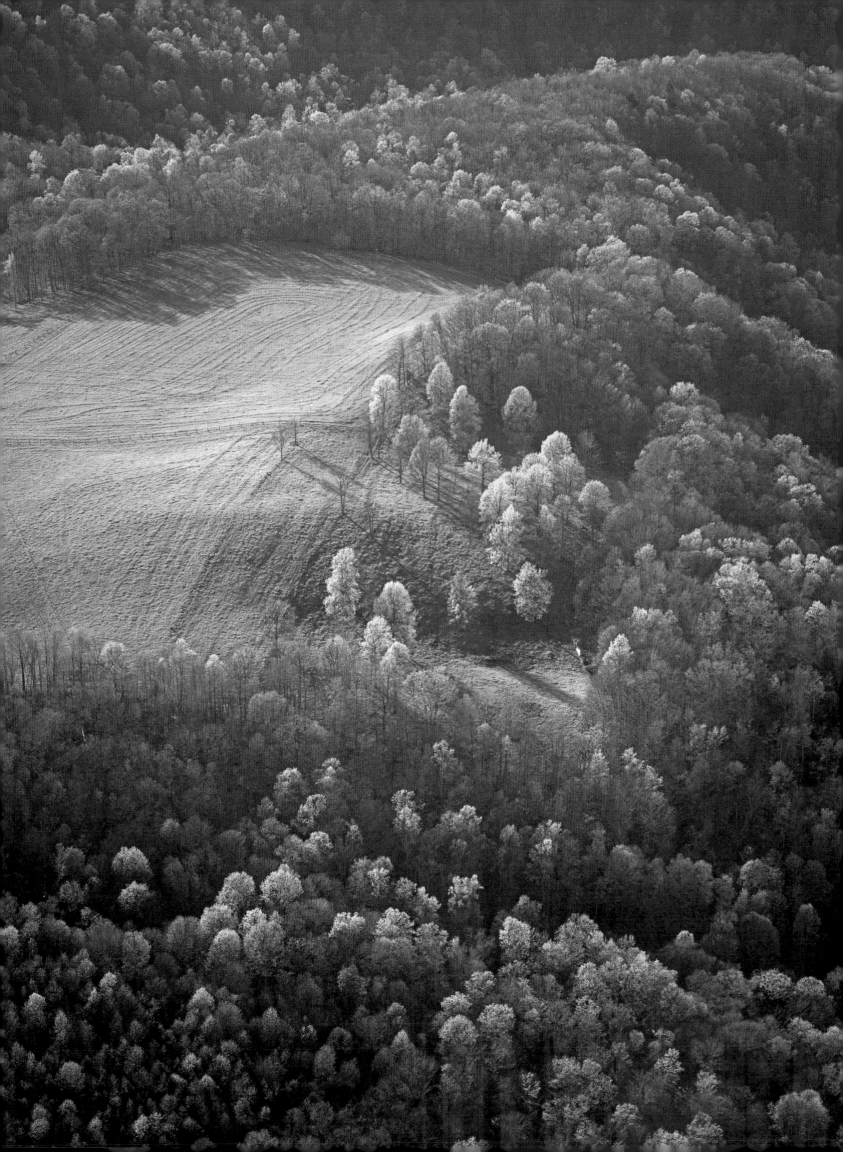

*Left: The Appalachians record three moun-
tain-building events that began 450 million
years ago. Each time, Europe and Africa
crashed into North America from the east.
Consequently, the Appalachians are most
deformed on their eastern side. These mildly
wrinkled hills along the Gauley River in
West Virginia are carved into aprons of sedi-
ment that were shed westward from higher
portions of the Appalachian Mountains.*

*Right: The Allegheny Plateau, which is
within the Appalachian Highlands
Province and stretches toward mid-conti-
nent from the Blue Ridge and Valley and
Ridge Districts is made up of sediments shed
westward from the Appalachian highlands.
The Plateau's layers of sandstone, shale,
limestone, and coal were laid down about
300 million years ago. Erosion has had
plenty of time to soften the edges of this
ancient landscape.*

Compression has also been a dominant theme throughout much of the American West. But unlike that of the Appalachian Highland Province, this compression was generated not by a continent-continent collision, but primarily by the subduction of oceanic crust beneath the western edge of the North American continent. Many western provinces were fashioned by different stages of this collision, which began about 150 million years ago. The show started during the heyday of the dinosaurs, when the floor of the Pacific Ocean first flexed down and then dove beneath North America. Active subduction continues today beneath the coastlines of the Northwest, as well as Alaska and its Aleutian Islands.

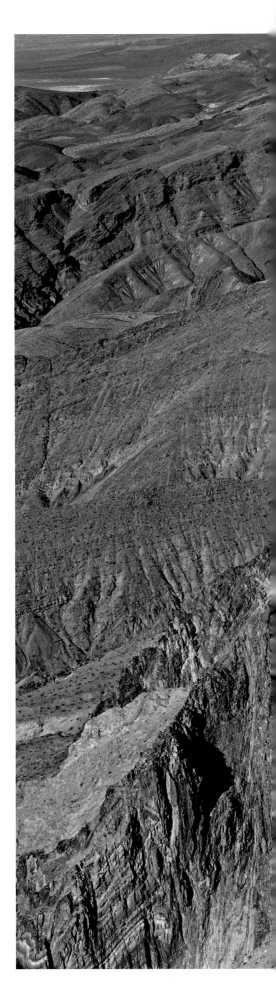

Sedimentary layers in California's Death Valley National Park were originally deposited in flat sheets of limestone, sandstone, and shale. But the rocks were caught in a continental-scale vise, so that deeper older rocks were thrust up and over these sedimentary layers along a fracture called the Last Chance Thrust Fault. The layers were twisted into the crazed and convoluted shapes now visible below Ubehebe Peak.

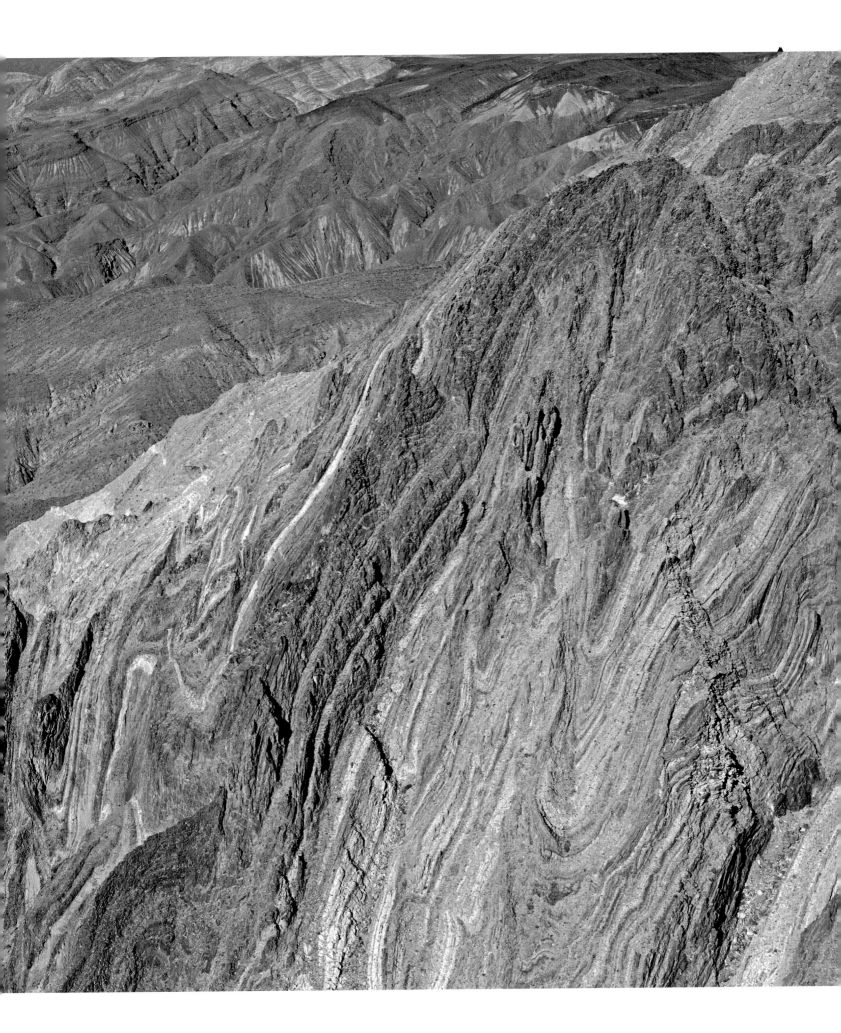

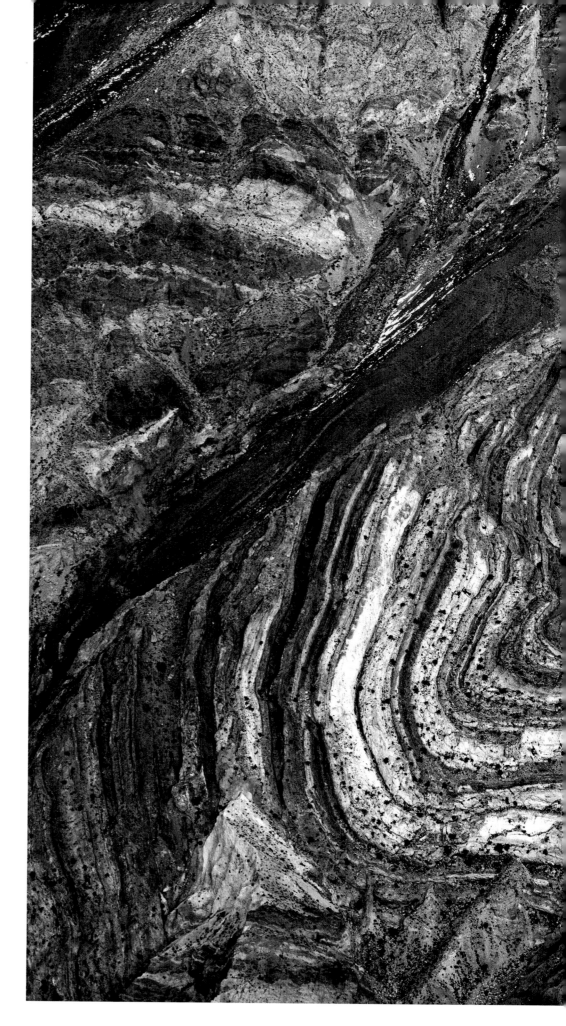

The black and white stripes of limestone in the Cottonwood Mountains of Death Valley National Park were originally deposited as flat beds at the bottom of a peaceful ocean. But these layers, thousands of feet thick, were compressed about 200 million years ago and folded back upon themselves in an incredible display of forces that exist within the earth.

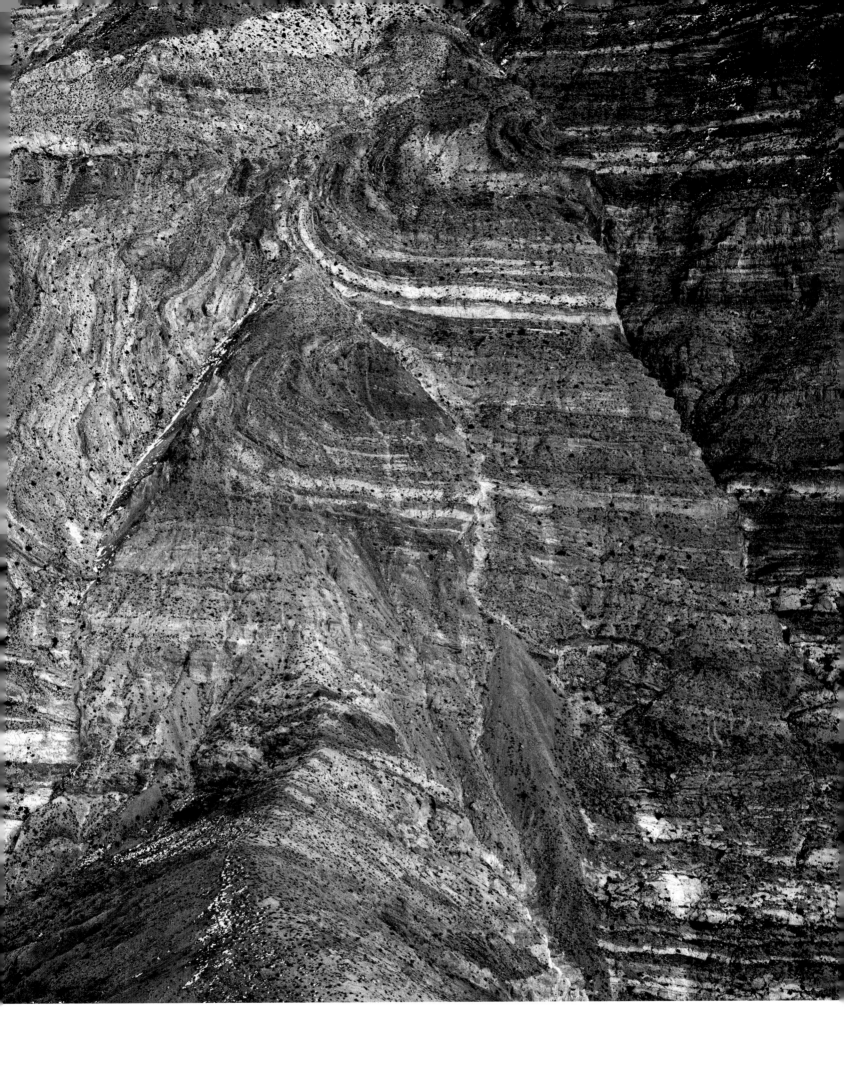

Many rocks throughout the West reflect a compressive heritage. The Cascades occupy the northwest corner of the Columbia Plateau Province in Oregon and Washington. These mountains are still being created by the subduction of lingering fragments of the old Farallon Plate beneath North America. In places, these mountains are rising half a mile every million years. As it approaches North America, the Pacific Ocean floor accumulates layers of silt and sand shed from the continent. Upon reaching the subduction zone, some of these sediments are scraped off against the leading edge of North America like peanut butter smeared from a knife onto a piece of bread. Thus the Cascades are a hodge-podge of crumpled sedimentary and volcanic rocks, with a handful of metamorphics thrown in for good measure.

Mount Baker is a (barely) dormant volcano within the North Cascade Range, which sits atop a subduction zone beneath western Washington. Ash and smoke occasionally curl up from Mt. Baker's 10,735-foot summit, reminding us of its violent past and hinting at the mountain's stormy future.

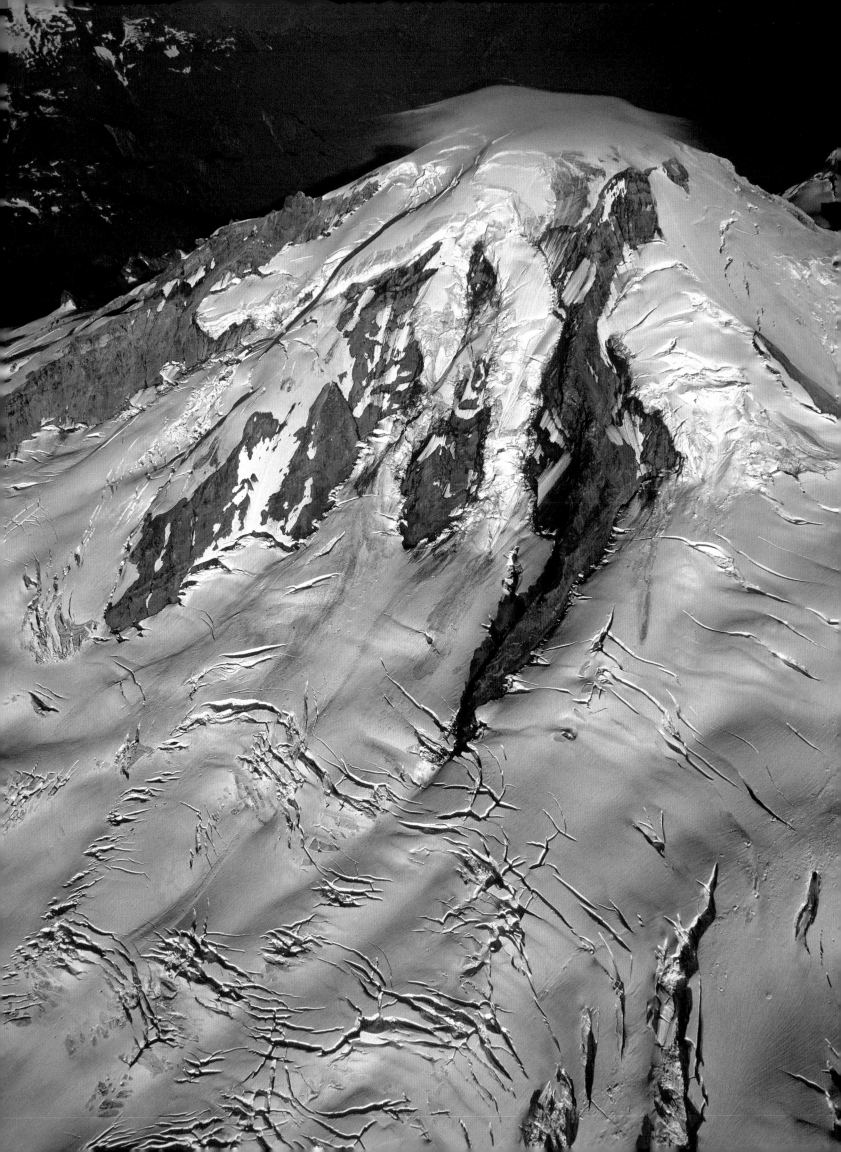

The North Cascades are a jumbled range
resulting from the plate collision that
continues beneath the feet of Seattle and
Portland today. The range is remarkably
steep and difficult to traverse.

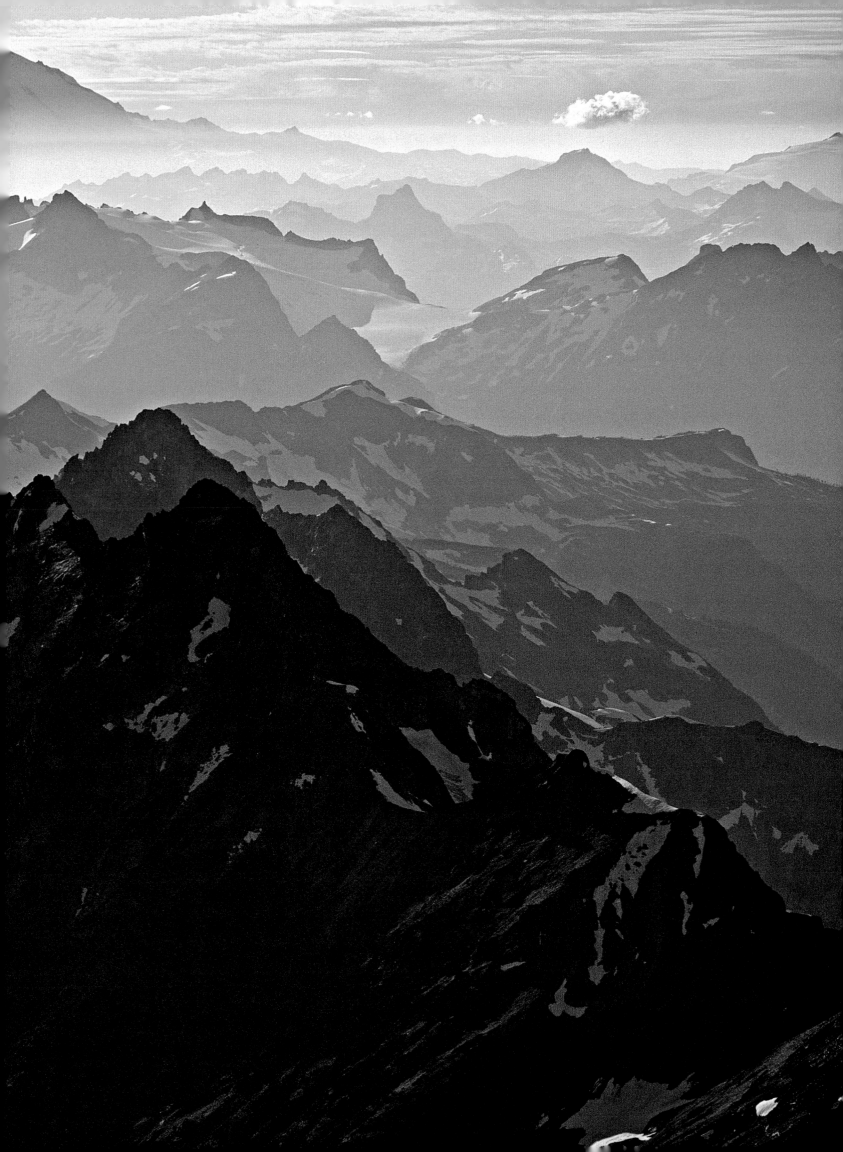

From the active subduction zone of the Cascades, let's turn our attention to other provinces that have been formed by tectonic compression. Much of western North America is mountainous, with ranges that extend well inland from the Pacific coast. At first blush, this seems at odds with a fundamental tenet of plate tectonics—that colliding plates deform along their edges, not within their interiors. But it's hard to argue with the facts: Pikes Peak in the Colorado Rockies is almost a thousand miles east of the Pacific Ocean. The Rocky Mountains and many other inland ranges were created by the Pacific plate/North American plate collision, but by different processes than we saw in Washington and Oregon.

How did these inland mountains form? Beneath the Cascade Range, fragments of the old Farallon Plate are diving at the 45 degree angle typical of subduction. But elsewhere the plate might not descend so steeply. It's possible that the descending crust didn't cool sufficiently, and might have been less dense and therefore less inclined to hurry down into the mantle.

This seems to have been the case beginning 65 or 70 million years ago, when a large piece of the Farallon Plate first began to slide under inland portions of the American West at an unusually low angle. That shallow subducting plate is thought to have scraped along the underside of North America, imparting a dramatic shearing force to the western third of the overlying continent during a turbulent time known as the Laramide.

Wyoming was ground zero during the Laramide, a mountain-building period named for the sleepy cow town of Laramie. During the Laramide, Wyoming and the surrounding Rocky Mountain Province were squeezed by east-directed pressure generated by shallow subduction of the Farallon Plate. That shearing pressure forced previously undisturbed sedimentary layers to fold like thin rugs pushed across a slippery floor. Sheep Mountain in the north-central part of Wyoming clearly shows how rock layers buckle up to create a mountain. Geologists call this shape an anticline.

Sheep Mountain is an anticline with rocks dipping away from its ridgeline on both sides. The sedimentary rocks on its flanks were once continuous flat sheets of sandstone and shale, but they were folded into this anticlinal shape when this region was compressed 65 million years ago. Now erosion is peeling back the layers like skin from an onion.

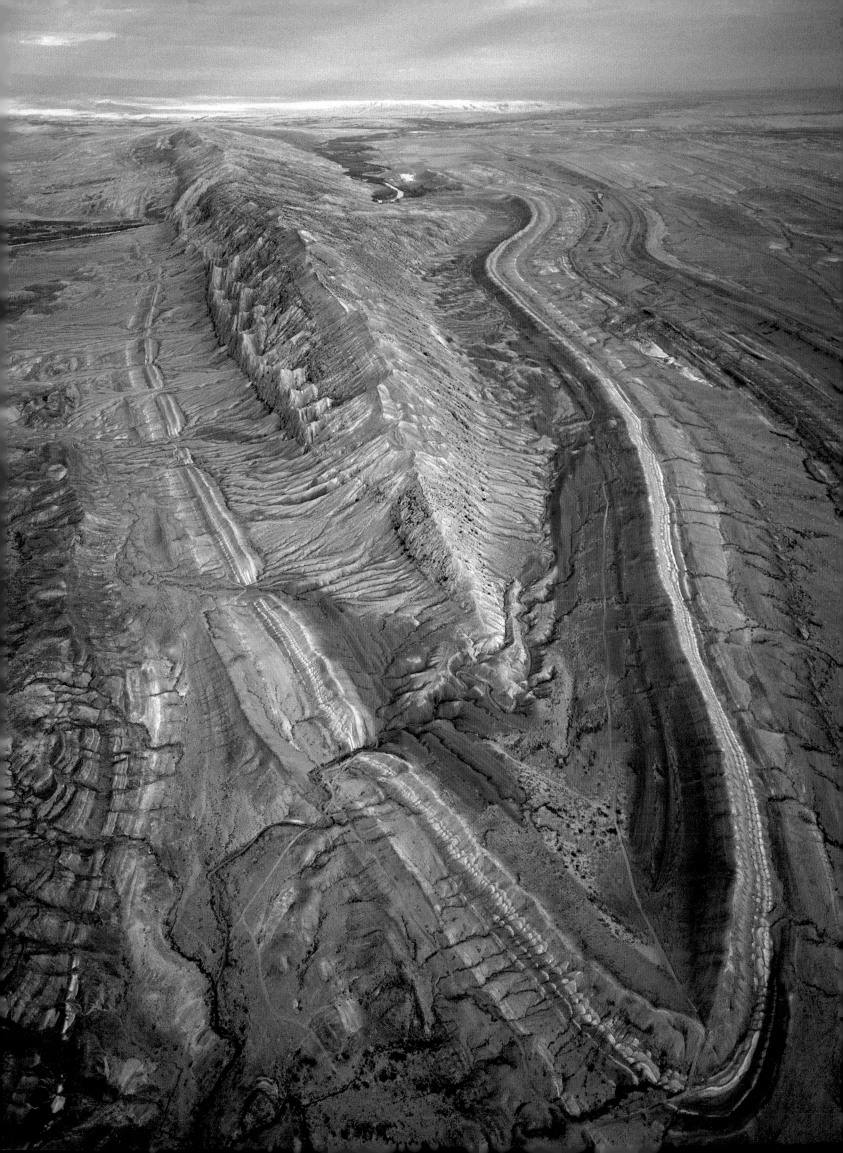

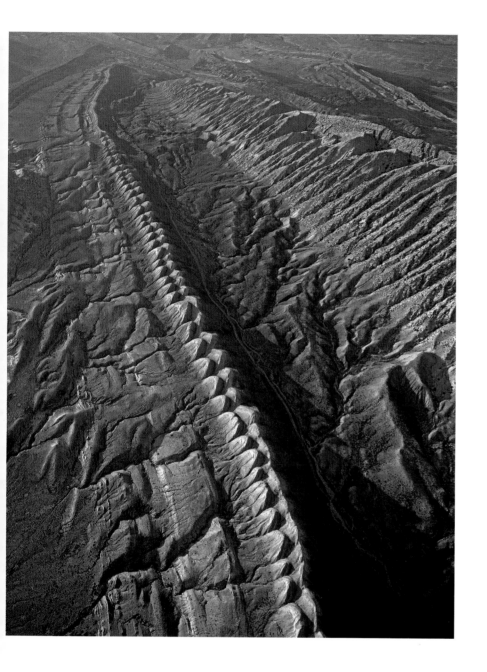

Sheep Mountain is hardly impressive by Wyoming standards—not quite 5,000 feet above sea level, rising barely a thousand feet above the surrounding countryside. Nevertheless, I find it impossible to look down and deny that something stupendous happened here—layers of rock thousands of feet thick, flexed like thin pieces of sheet metal! I don't know many other places where the bones of the earth lie so bare.

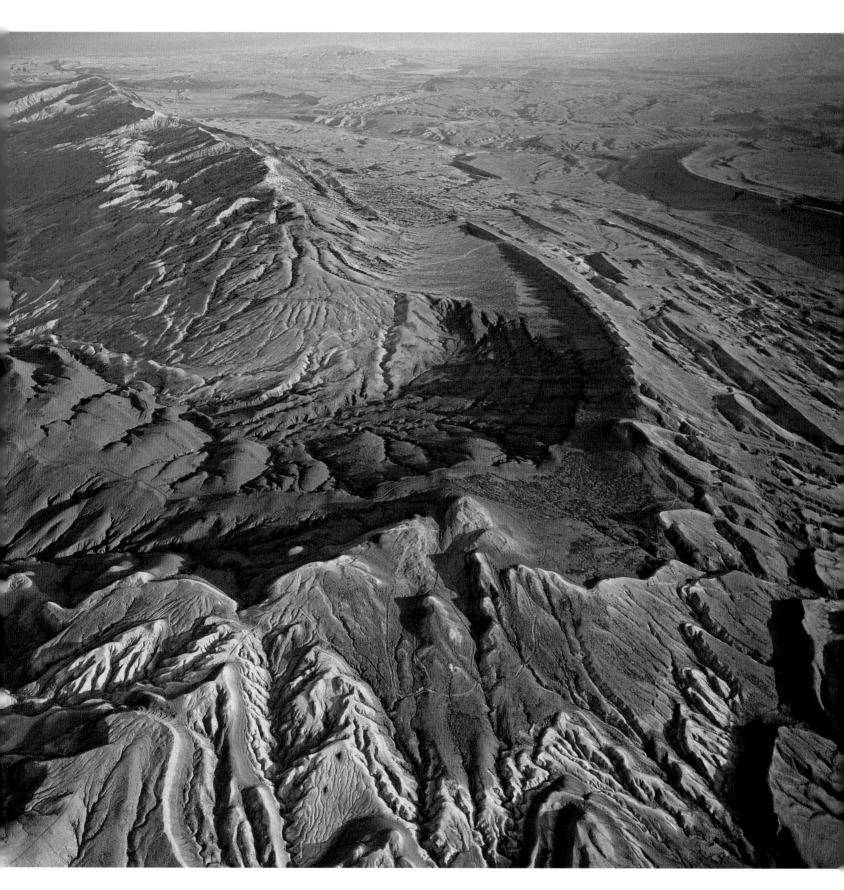

Sheep Mountain, Wyoming.

Scattered throughout Wyoming, Utah, and Arizona are related Laramide-era folds called monoclines that can be thought of as half-anticlines. Each has a single steepened face that looks like a wave about to crash onto a shoreline. Like Sheep Mountain Anticline, most monocline deformation is confined to the topmost sedimentary portion of the crust. Monoclines are a hallmark feature of the Colorado Plateau Province in southern Utah and northern Arizona—a land of uplifted but otherwise relatively undisturbed sedimentary rocks.

The Waterpocket Fold is a monocline in south-central Utah formed when sedimentary rocks were squeezed, buckled, and then tilted down to the left. Ephemeral streams racing from highlands on the right have carved many small canyons and isolated triangular chevrons of rock called flatirons. The monocline nicely exposes individual sedimentary formations, each seen as a discontinuous band of tan, red, or cream-colored rock running from top to bottom through the picture.

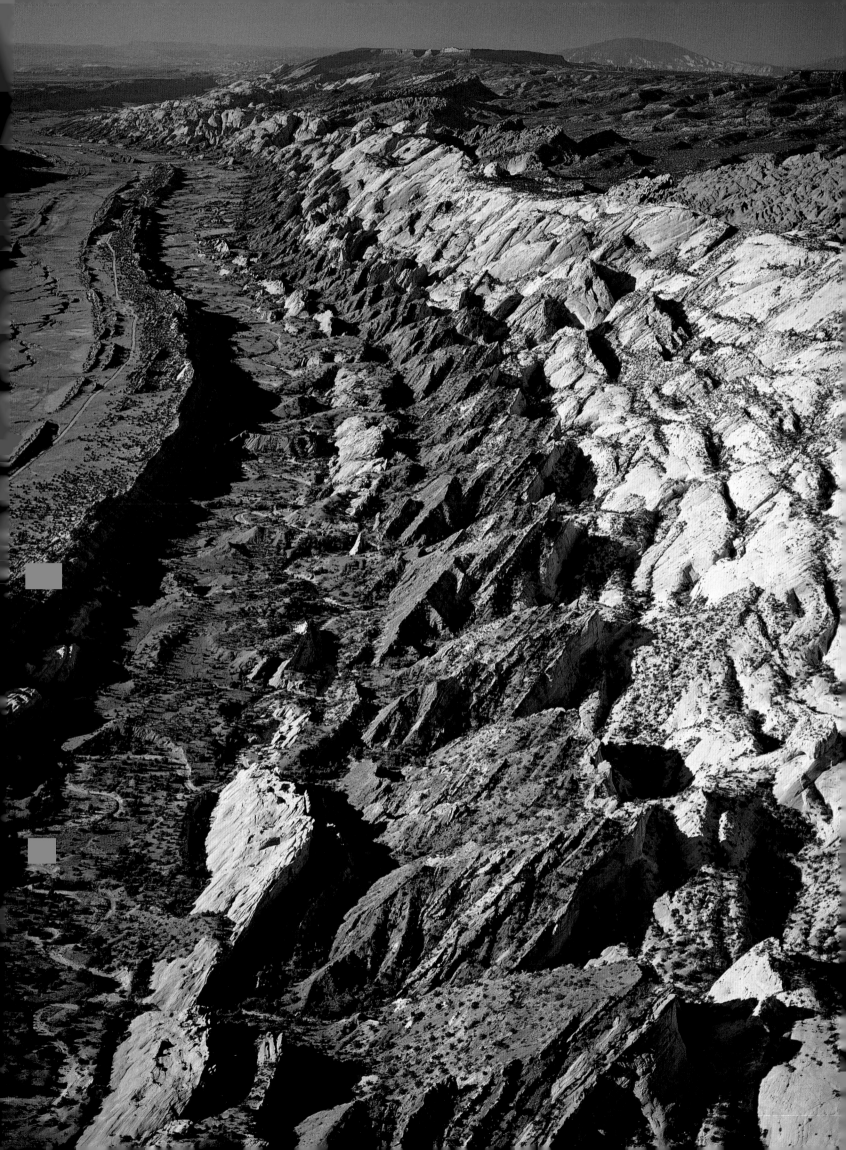

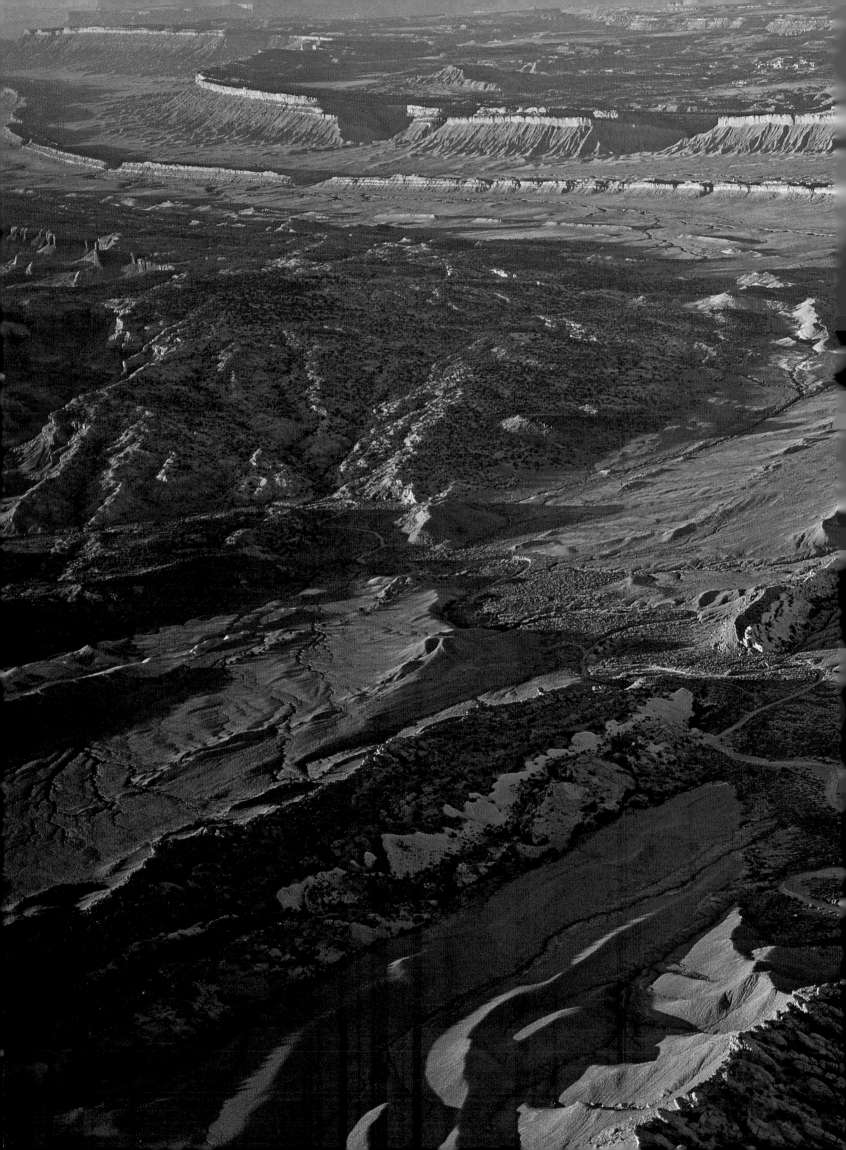

These rock layers were tilted at the same time the Waterpocket Fold was created in nearby Capitol Reef National Park. Erosion has worn down soft layers of shale, leaving more resistant sandstone to form the crest of each ridge.

In contrast, other Laramide-age mountains in the West were bull-
dozed up from deep within the crust, exposing cores of ancient granite
and metamorphic rock. Continental crust is divided into two types.
Down deep lie basement rocks, typically metamorphics like schist and
gneiss, as well as igneous rocks like granite. Perched above is a neat stack
of sedimentary layers, such as sandstone, shale, and limestone. In most
cases, a great gap in time separates the two types of rock, time enough to
have ground older mountains down to sea level before depositing the
younger sedimentary layers on top.

Unlike monoclines and anticlines, which involve only the uppermost
sedimentary layers, other Laramide ranges within the Rocky Mountain
Province were scooped from the basement, dredging up old igneous and
metamorphic rocks that still sport a cover of younger sedimentary rock.
Much of the vertical uplift of these mountains was accomplished by a
stuttering, staccato movement along steeply pitched thrust faults, rather
than by the more gentle folding responsible for monoclines or anticlines
such as the Waterpocket Fold in Utah or Sheep Mountain in Wyoming.

The Wind River Range is a stunning string of jagged peaks that rises
abruptly out of western Wyoming's sagebrush and alkali flats. A mantle of
sedimentary rock still covers the flanks of this range, but basement rocks
are exposed everywhere throughout its central highlands. The Rocky
Mountains that form the spine of North America from New Mexico to
Canada were also scooped up from deep-seated basement rocks during
Laramide deformation.

The Wind River Mountains create an impressive barrier that spans much of western Wyoming. The mountains are composed of continental basement rock that was thrown skyward by Laramide compressive forces. Glaciers have since hollowed out high cirques—the deep valleys seen here surrounded by flying buttresses of granite. Frightfully cold glacial tarns perch within many of the cirques.

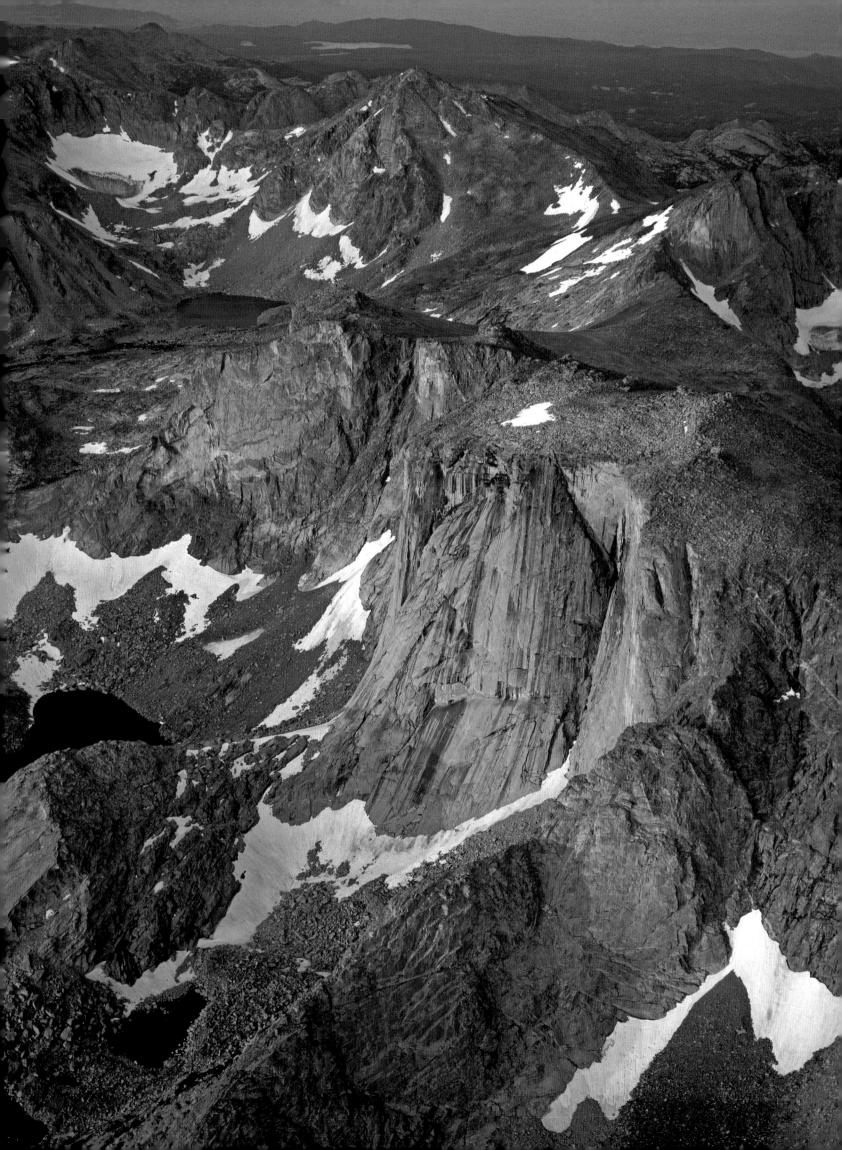

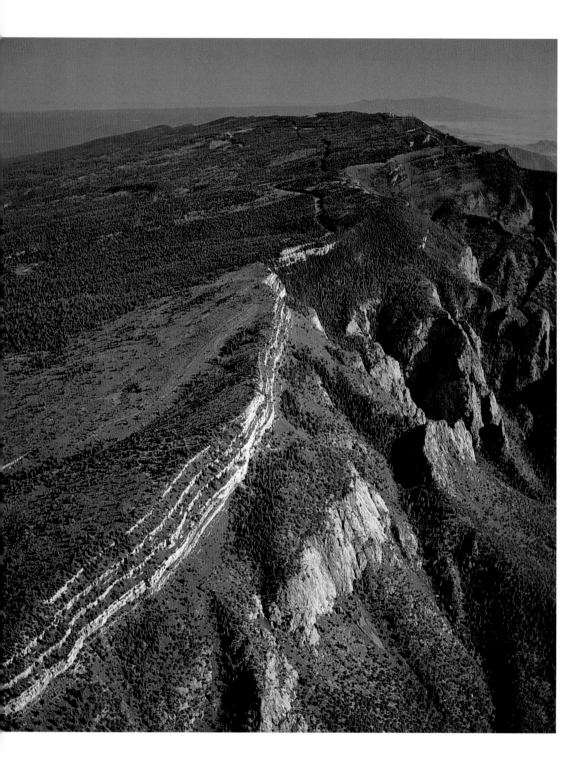

Left: The Sandia Mountains have been lifted a mile above Albuquerque, New Mexico, exposing both the lower basement rock on the right, and the younger sedimentary layers to the left.

Right: In the broadest sense, the Rocky Mountains run from Canada to Mexico. But the portion that extends from southern Wyoming to New Mexico is unique. These central and southern Rockies were formed during the Laramide when shallow subduction squeezed the overlying continent and propelled deep basement rocks up along near-vertical faults.

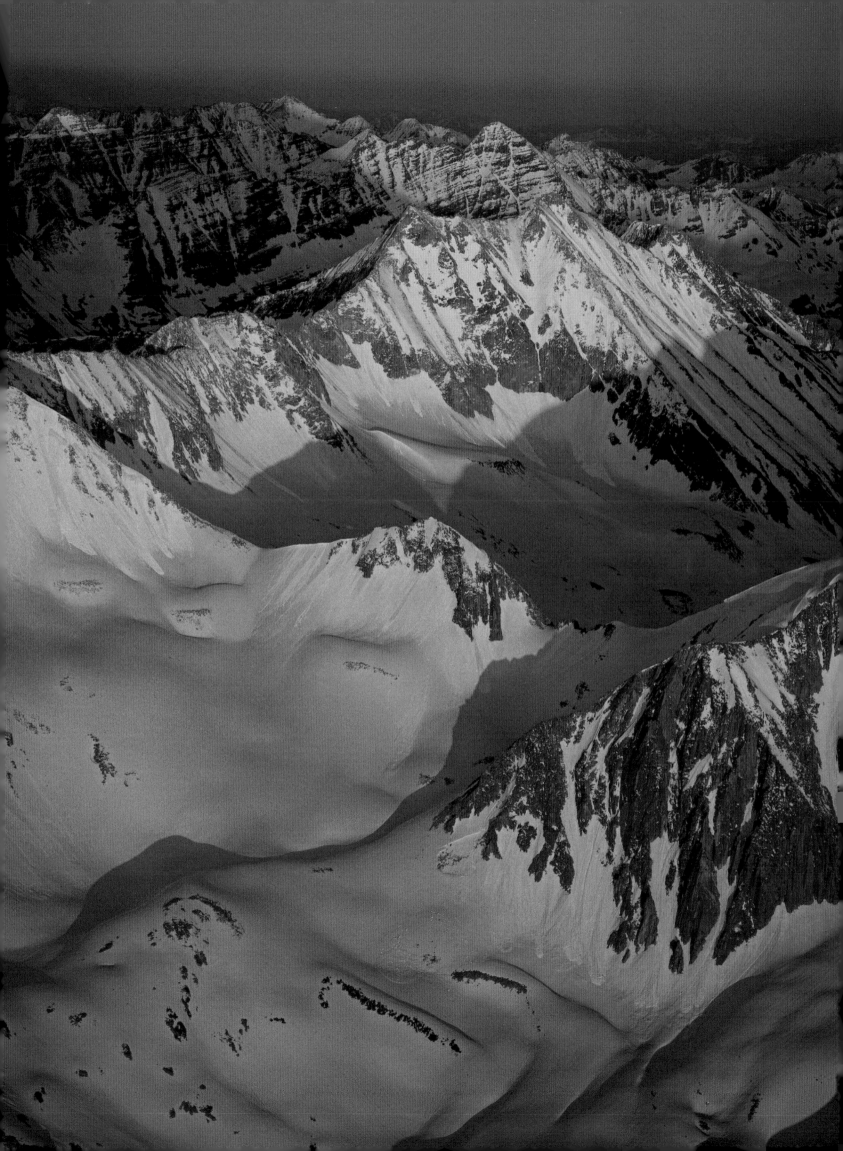

Sedimentary rocks still drape over the eastern flank of Wyoming's Wind River Mountains, though erosion has succeeded in chiseling them into these pointed, upward-angled flatirons. The layers—Madison Limestone on top, Tensleep Sandstone, and Chugwater Group below—were tilted when the basement core of the range was uplifted during the Laramide.

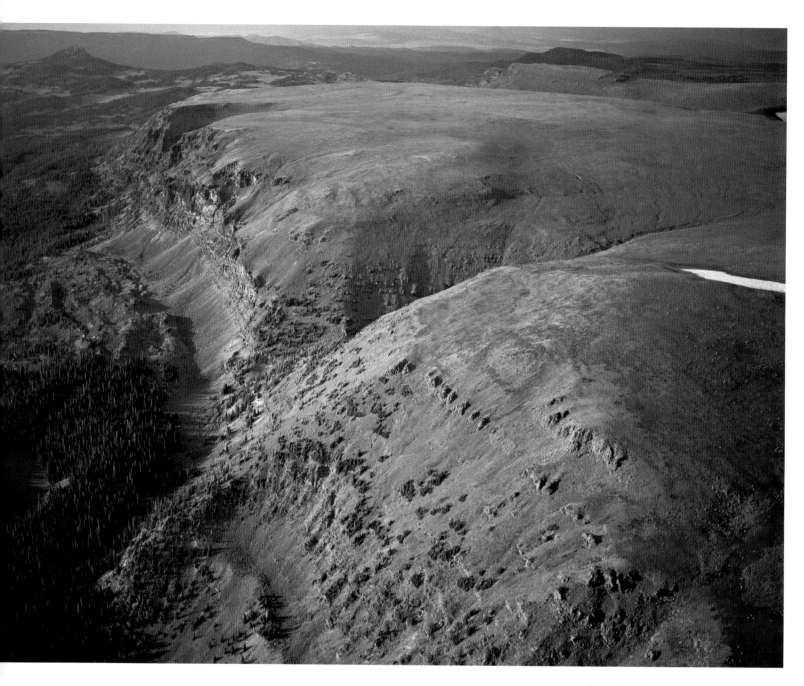

Above: The White River Plateau lies within the Flat Tops Wilderness north of Glenwood Springs, Colorado. The plateau was uplifted during the creation of the Rocky Mountains 65 million years ago, and is now frosted with younger basalt layers that smoothly cover the uplifted mountains.

Right: Rocks of Treasure Mountain in west-central Colorado have been lifted miles above the seafloor where they were first deposited hundreds of millions of years ago. Later they were tilted and then exposed, here revealing the telltale layering of their sedimentary origin.

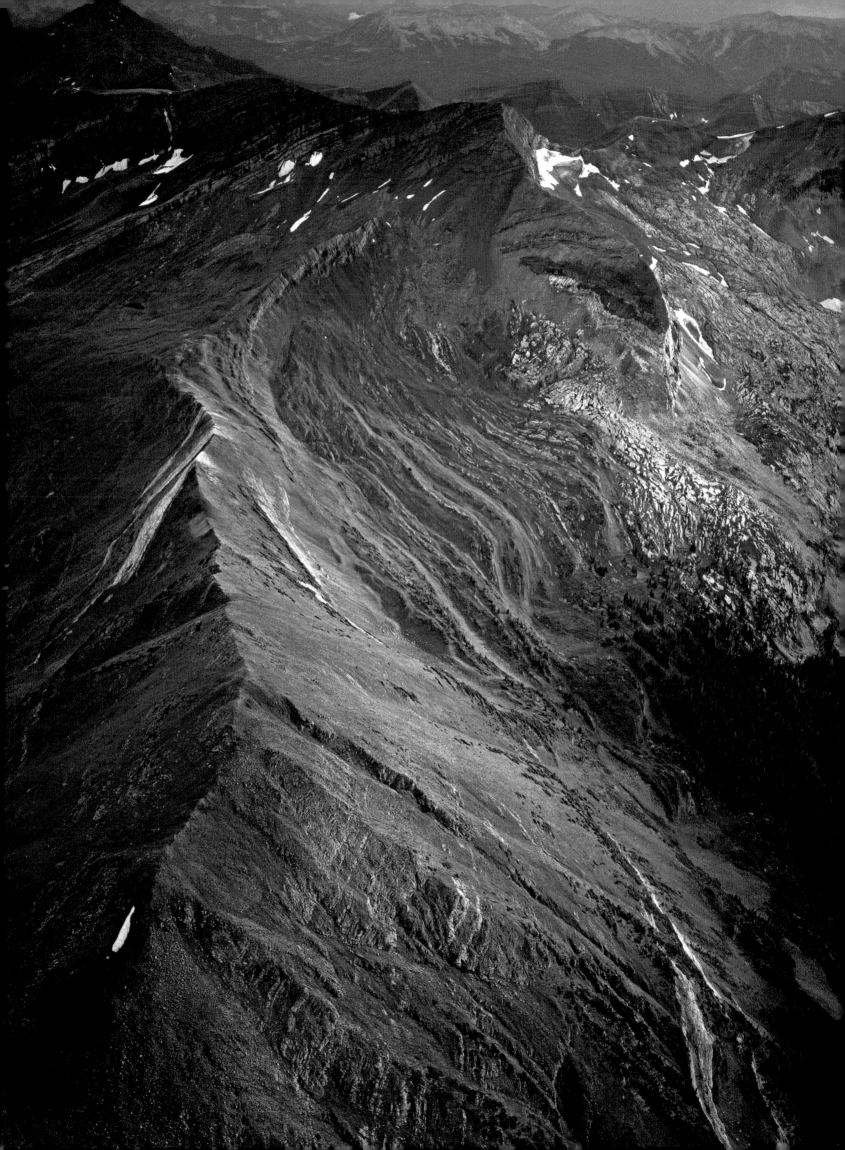

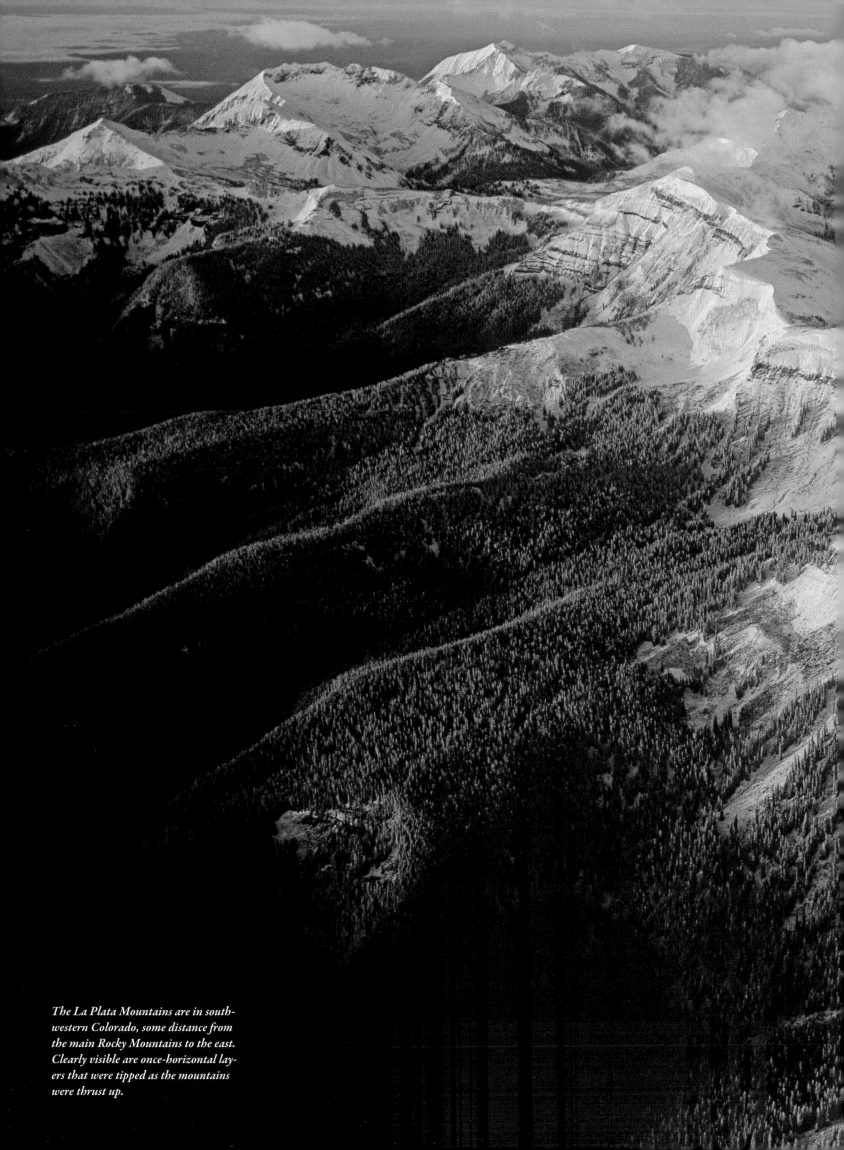

The La Plata Mountains are in southwestern Colorado, some distance from the main Rocky Mountains to the east. Clearly visible are once-horizontal layers that were tipped as the mountains were thrust up.

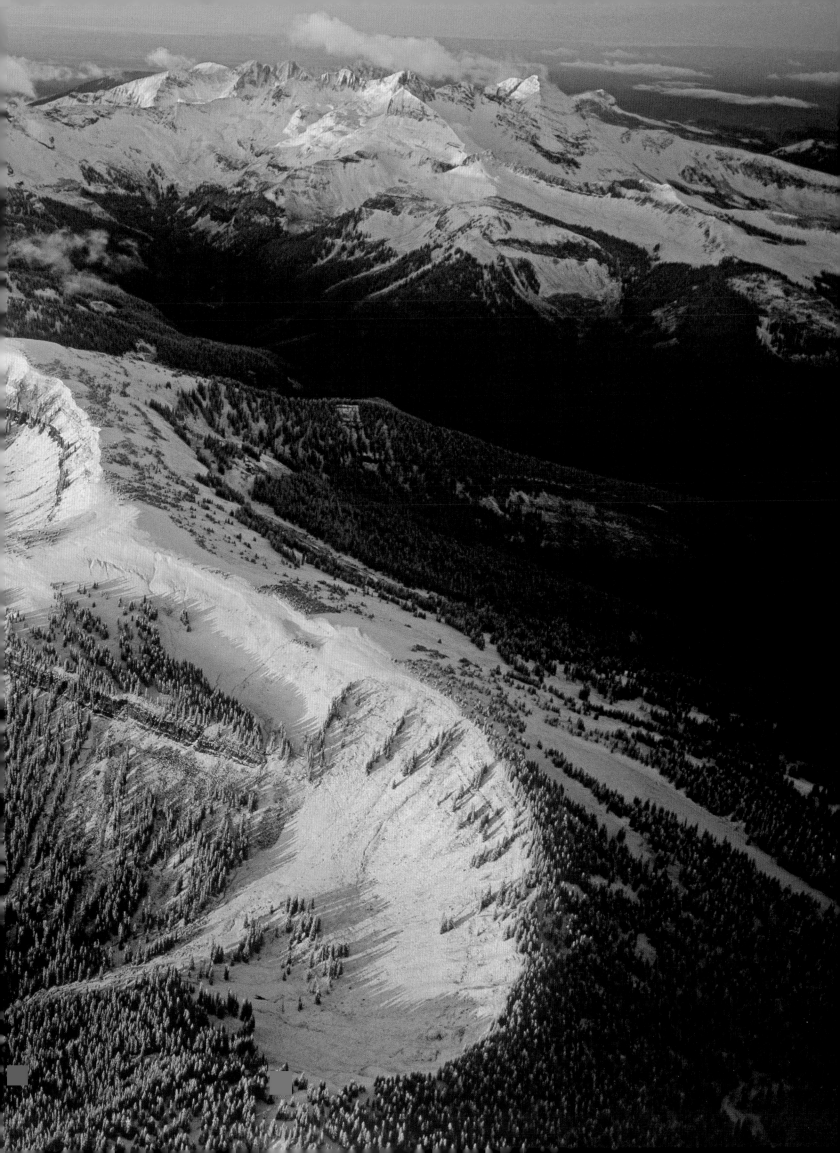

Colliding crusts are not always looking for an excuse to take a dive. A splinter of continental crust might be embedded in an ocean plate, the remnant of an earlier collision, a piece of shrapnel picked up on the plate's path to subduction. Imagine a towering iceberg (continental crust) locked into a thin frozen sea surface (ocean crust), moving in unison. The iceberg projects both higher into the air and deeper into the ocean than the thin sea ice. If this entire crustal assemblage is chugging toward a collision with, say, Alaska, there is a good chance that the buoyant continental crust is going to be scraped off, rather than diving down with the subducting oceanic crust. Of course, this piece of newly attached continent—called a suspect terrane—will have a very different geologic history than the old Alaskan continent to which it is now annealed.

That is exactly what happened 150 million years ago when a great block of continental crust called Wrangellia cruised past California, up from the latitude of what is now San Diego. Northbound Wrangellia was embedded in the Kula Plate, a piece of oceanic crust long since subducted beyond recognition beneath Alaska. Tanya Atwater is the quick-witted geophysicist who named this former plate, borrowing the Athabascan word for "all gone." Sixty million years ago, a small ocean basin was formed between the two converging land masses. The basin was caught between a rock (Wrangellia) and a hard place (Alaska), and received sediments from both directions. The sedimentary layers were doomed to immediate deformation, squeezed as they were between the colliding terranes.

The Cantwell Formation is found along the north side of the Alaska Range in Denali National Park. These layers were folded back on themselves when a huge continental block called the Talkeetna Superterrane crashed into Alaska from the south. These folds are now exposed where the East Fork of the Toklat River has eroded its way out of the Alaska Range.

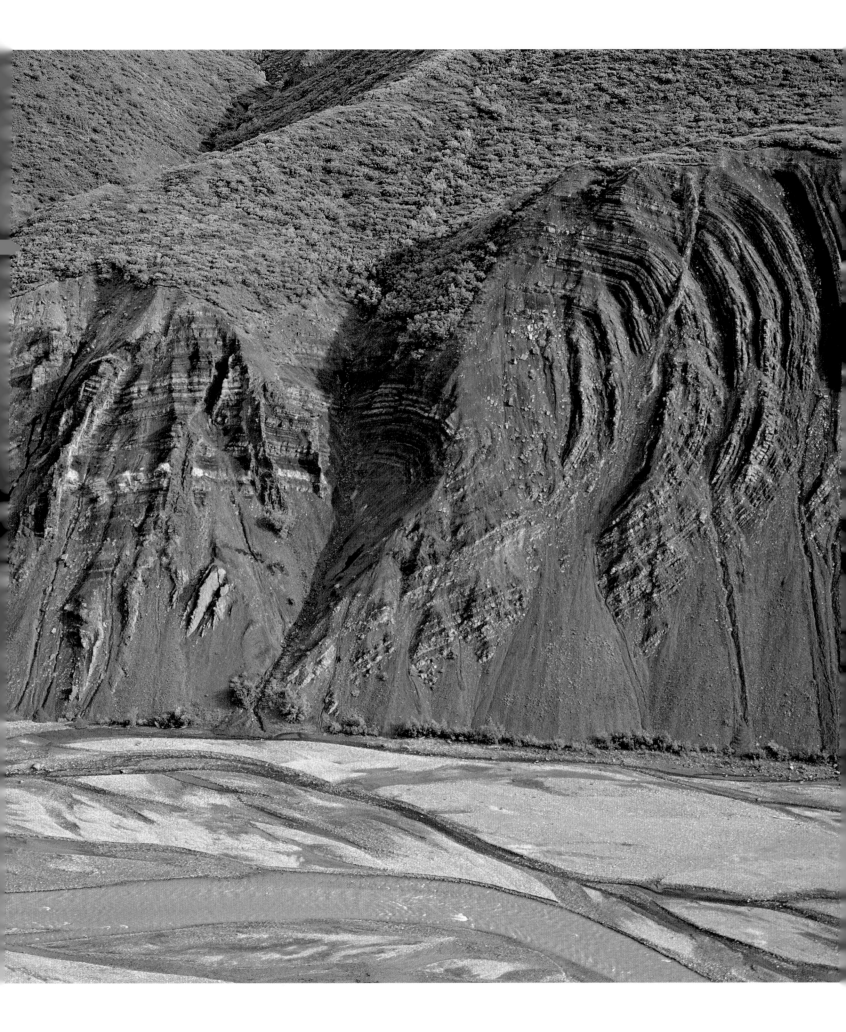

The Cantwell Formation is 60 to 70 million years old, a 5,000-foot hodgepodge of limestone, chert, sandstone, and quartzite. In places, the formation's sedimentary strata were injected with magma that froze into the thin black ledges called dikes, seen at the lower right of this picture.

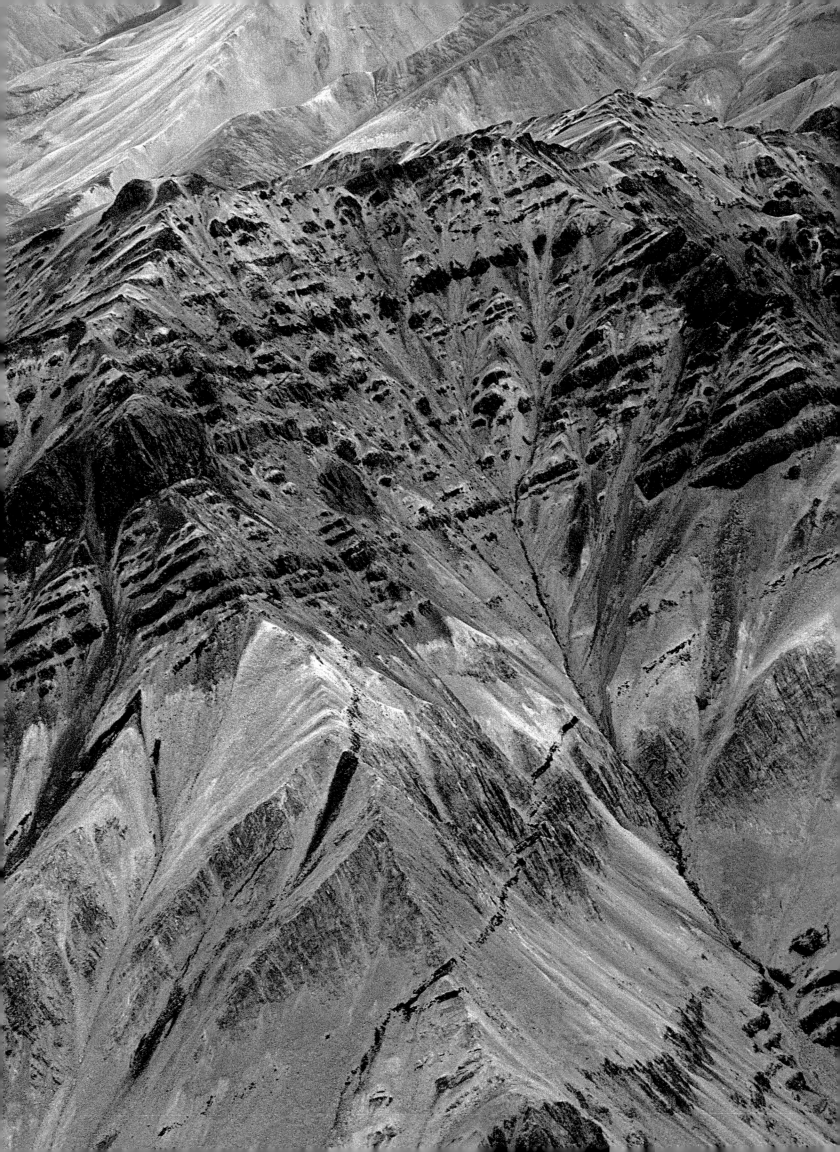

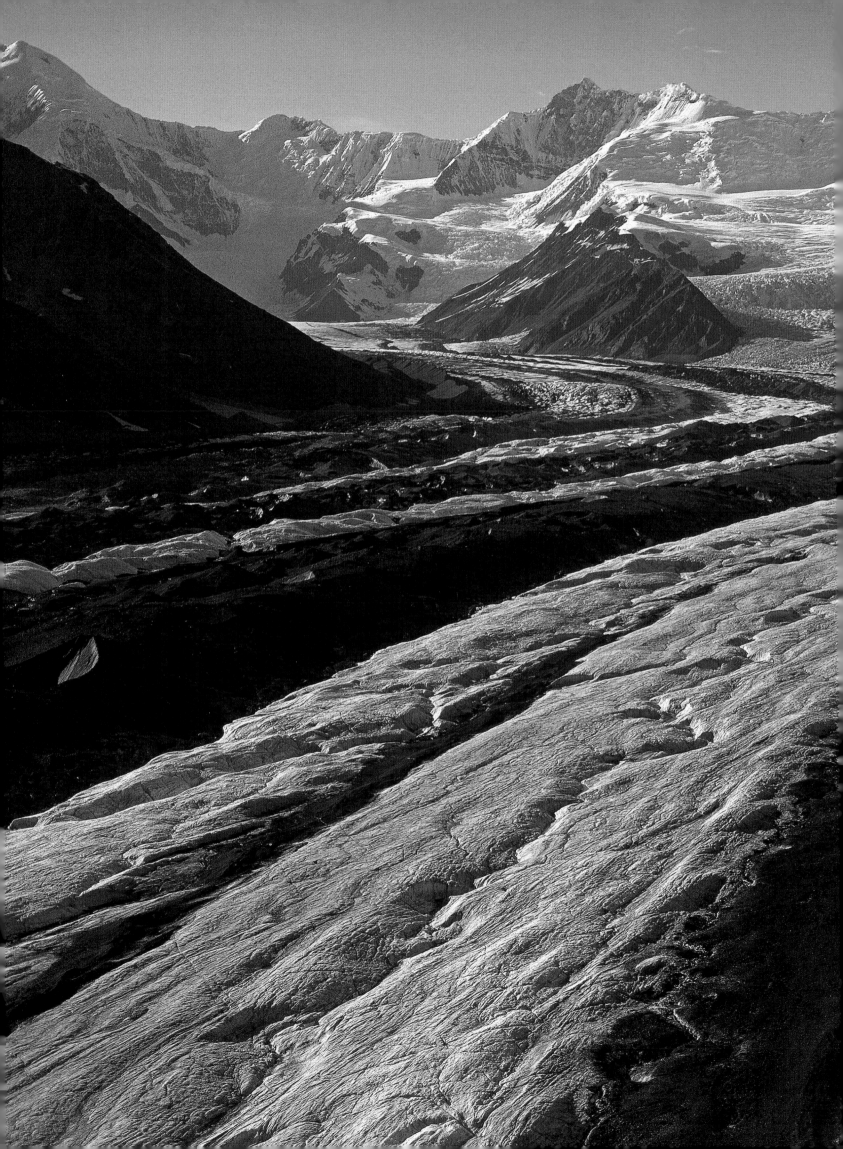

The Kennicott is one of many glaciers now dismantling the Wrangell Mountains in Alaska. These mountains lent their name to the suspect terrane known as Wrangellia.

Rather than mountains created by compression, let's now examine ones produced instead by tension. The Basin and Range Province is centered on the high deserts of Nevada and spills into portions of California, Oregon, Arizona, New Mexico, and the westernmost edge of Wyoming. This huge area is characterized by hundreds of parallel mountain ranges, all aligned roughly north-south. One nineteenth-century geologist likened this landscape to a mighty fleet of ships at anchor, all swung into a wind out of the north. Between the ranges are basins that have filled with thousands of feet of debris shed from the nearby mountains. Many rivers in the Basin and Range Province don't drain to the sea; instead they flow into enclosed playas where water can escape only by evaporation, leaving their loads of sediment behind.

The Amargosa River flows into, but not out of, Death Valley. The water is trapped, escaping only by evaporation—which doesn't take too long when summer temperatures climb above 130° Fahrenheit on the valley floor. Thousands of feet of evaporites now fill the valley floor—salts left behind by evaporation of the Amargosa. These deposits have been mined for borax and colemanite, most famously transported by the Twenty Mule Team wagons of the 1880s.

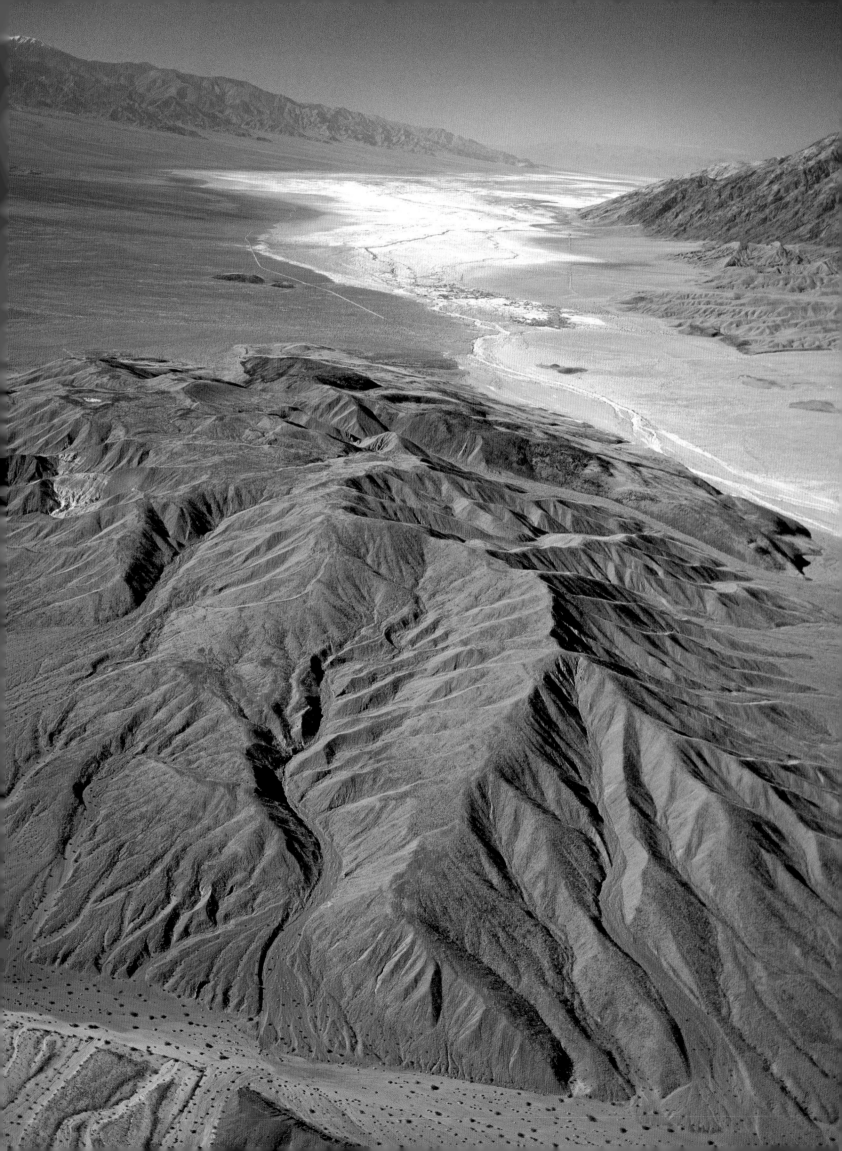

The ranges of the Basin and Range Province are not aligned by mere coincidence. These mountains were created during a period of continental extension (not compression) that was well underway by about 20 million years ago and continues today. The province is being pulled apart from east to west. As it stretches, the crust is breaking along vertical fractures called normal faults, where basins literally slide down the face of their adjacent mountains.

Death Valley is one of these quickly sinking basins in eastern California. It is being pulled apart at the seams. In some places, rocks of the valley floor are sliding horizontally past one another, but purely horizontal motion doesn't directly create mountains. In most places, Death Valley is writhing in three dimensions, not just two. When motion is oriented up and down, rather than side by side, downdrops and uplifts occur and mountains spring up. There is every reason to believe that the Panamint Range on the west side of Death Valley was once not just alongside *but on top of* the Black Mountains that now lie on the east side of the valley. Think about that: an entire mountain range skittering along under the influence of gravity. A mountain, you say, just doesn't step on a banana peel and slide. But like it or not, this range did.

So how do basins-sliding-down create mountains-sticking-up? That's a tough one, but let me try to explain. Imagine a row of books lined up on a shelf. Stretch the shelf, and the covers will slide past each other as the books begin to tilt. This causes some of the corners to slip down (into basins) while others seem to rise up (into ranges). At the latitude of Las Vegas, the Basin and Range Province has stretched 150 miles westward in the last 17 million years. With this extension, mountains have risen while basins have fallen.

The Artists Drive Formation is found at the northern end of the Black Mountains in Death Valley National Park. The valley floor lies to the left in this picture, plummeting down normal faults like the one visible as the bright vertical line that parallels the road. Death Valley exists because its basins have sunk beneath the surrounding peaks of the Black and Panamint Mountains along such vertical faults.

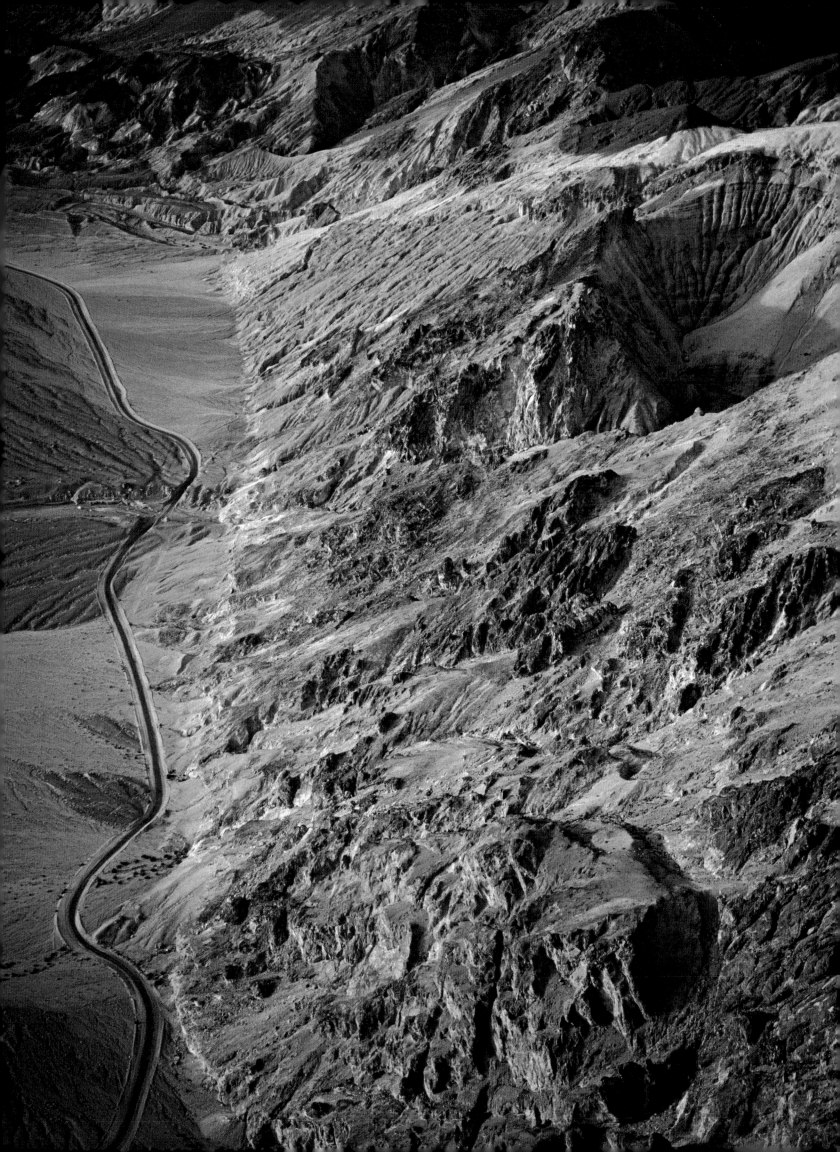

Death Valley National Park is being stretched out along the Furnace Creek Fault Zone that runs straight up the left side of this valley. Even though faults are ubiquitous throughout mountain landscapes, they are rarely so obvious as in this barren desert. Here, the fault announces itself as an anomalously straight line that separates the low alluvial hills in the center from the flat valley floor on the left.

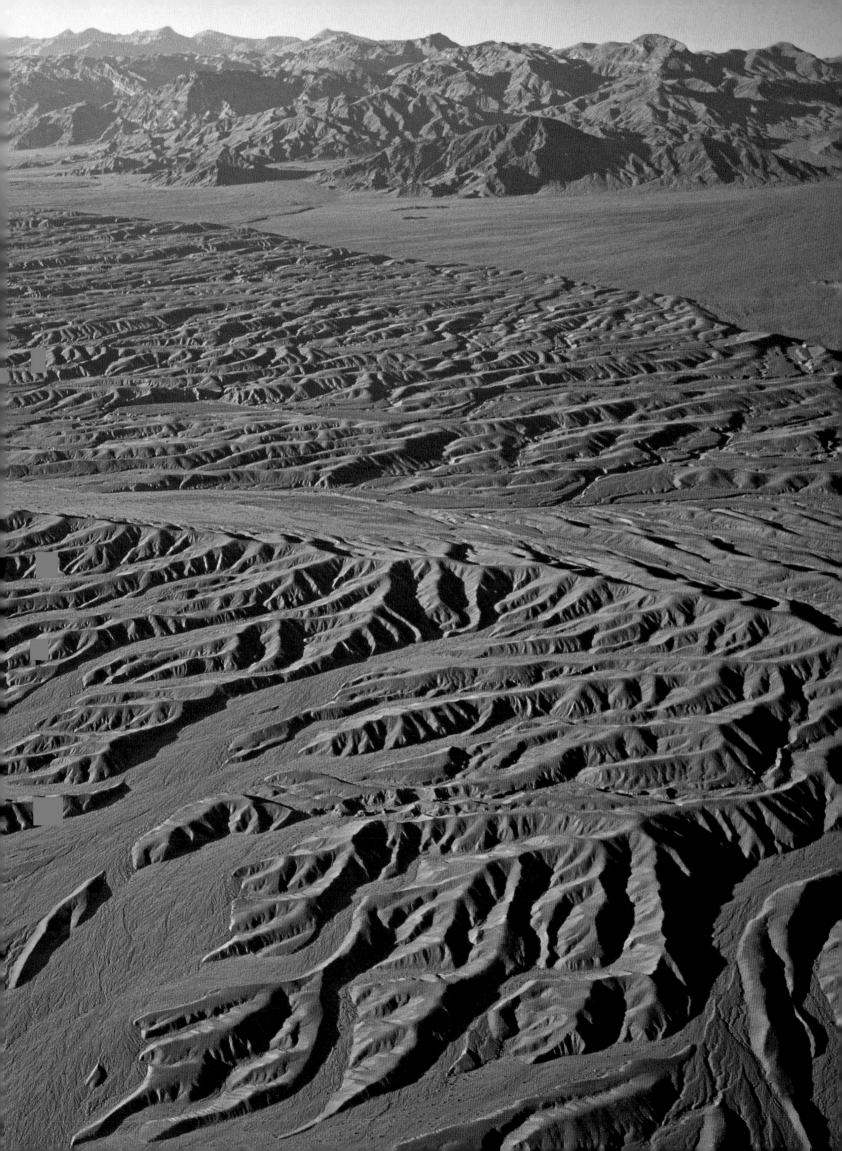

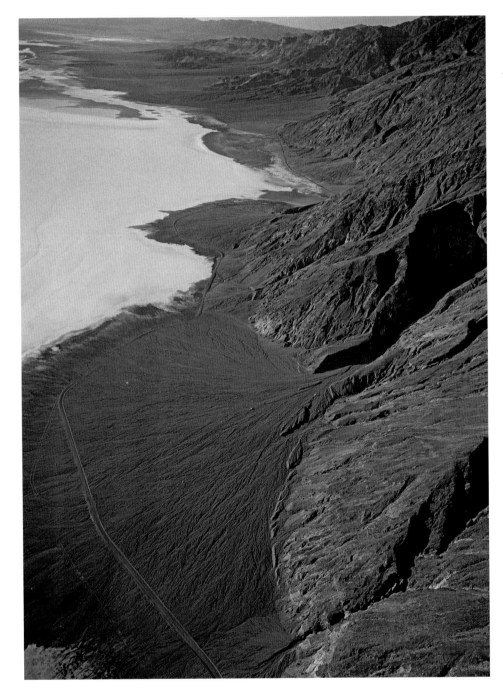

Left: At 282 feet below sea level, white-hued Badwater Playa is the lowest point in the Western Hemisphere. The beveled surface to the right dips toward the playa, plunging beneath the alluvial sediments that fill Death Valley. This surface, called the Badwater Turtleback, was ground and polished by the Panamint Range as it slid west off the turtleback. Since then, ravines have been hastily carved into the turtleback. These canyons spew prodigious amounts of recently eroded rock onto the valley floor, creating the cone-shaped deposits called alluvial fans seen at the bottom of the picture.

Right: Sedimentary layers within the Pogonip Group were originally deposited horizontally at the bottom of a sleepy sea, half a billion years ago. Since then, these rocks on the east flank of the Panamint Mountains have been dramatically pitched skyward even as they slid into their current position in California's Death Valley.

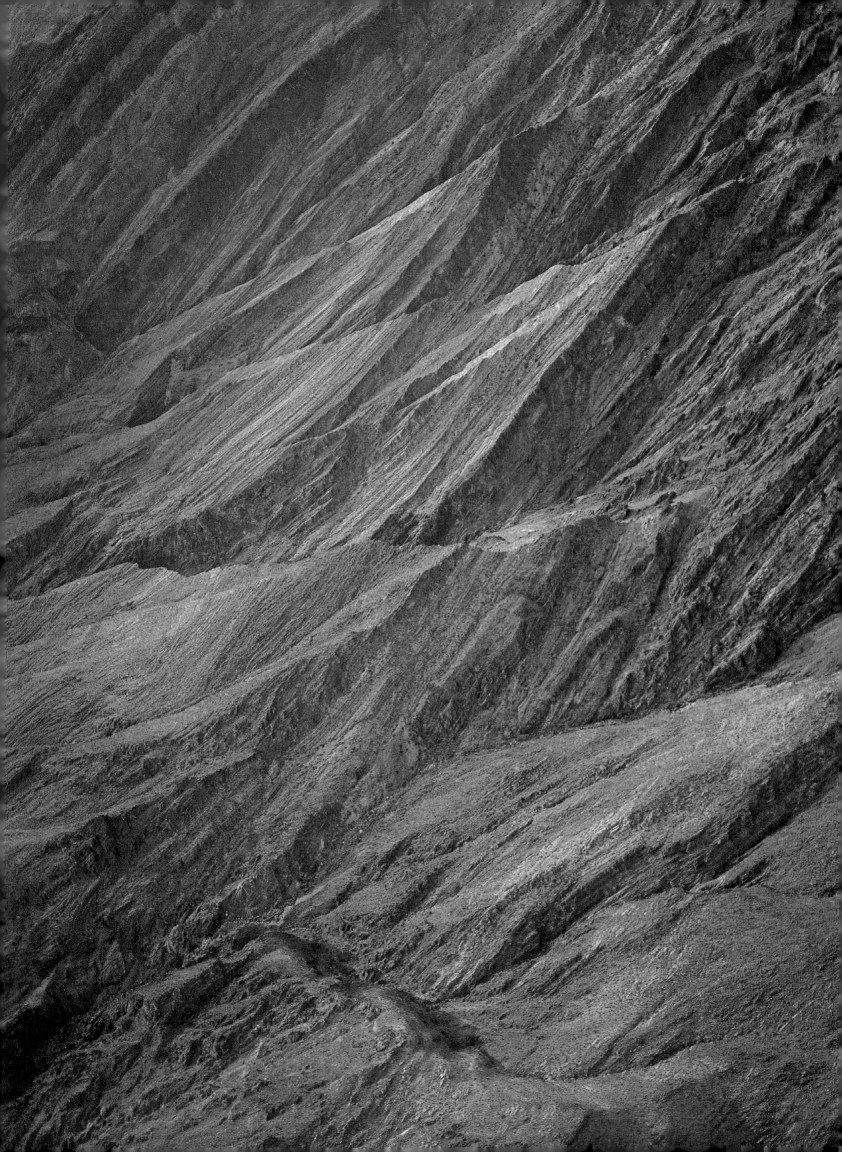

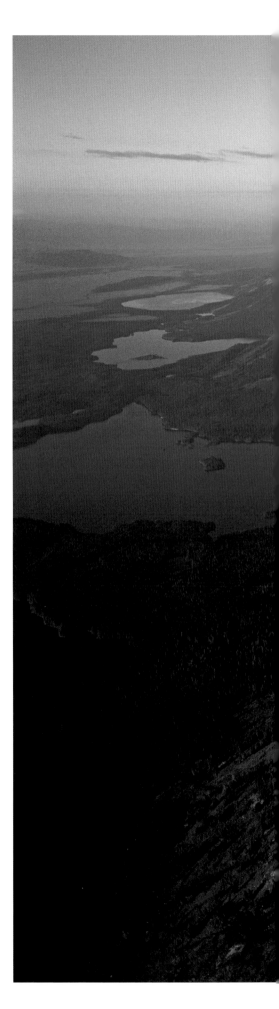

Death Valley brackets one end of the Basin and Range Province; western Wyoming is at the other end. At 13,770 feet above sea level, the top of Grand Teton is often hidden in clouds. This peak is the crown jewel of the Teton Mountains, one of North America's most beautiful mountain ranges. Basin-and-Range-style extension has migrated eastward across the province through time, arriving in the Tetons only five million years ago.

A string of lakes—Jackson, Leigh, Jenny, Phelps, and others—is aligned along the eastern edge of the Tetons. Alignments don't happen by accident in nature. The lakes sit astride a buried fault, which currently defines the eastern limit of the Basin and Range Province. This Teton Fault is an east-facing normal fault along which rocks have been alternately pitched up (on the west) or thrown down (on the east).

Adding up the layers raised and lowered on either side of the Teton Fault, geologists estimate that the mountains have risen 30,000 feet above the bottom of Jackson Hole basin. Erosion of the mountains and filling of the basin reduce this to the mere 7,000 feet that now vertically separates the summit of Grand Teton from the gilded streets of Jackson Hole. When the mountains and basin grind against each other, folks in Jackson Hole feel the earthquakes that periodically jostle western Wyoming. A magnitude 7.5 earthquake shook loose a huge landslide that dammed the nearby Madison River in 1959. More rumblings are sure to follow.

Lakes line the Teton Fault that separates the rugged high terrain of Grand Teton National Park from the lower Jackson Hole basin on the left. The shadowed valley of Moran Creek near the picture's center belies the region's Ice Age heritage. Glaciers scooped out this U-shaped canyon as they tumbled out of the Tetons towards Jackson Hole.

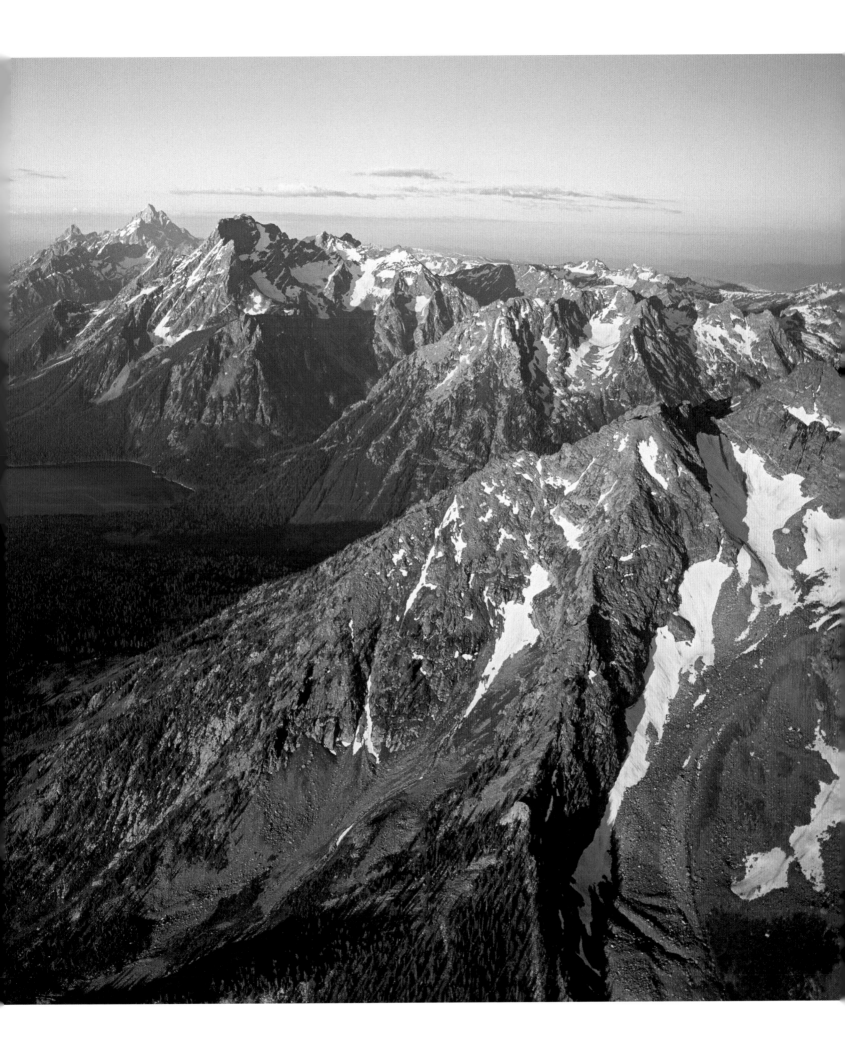

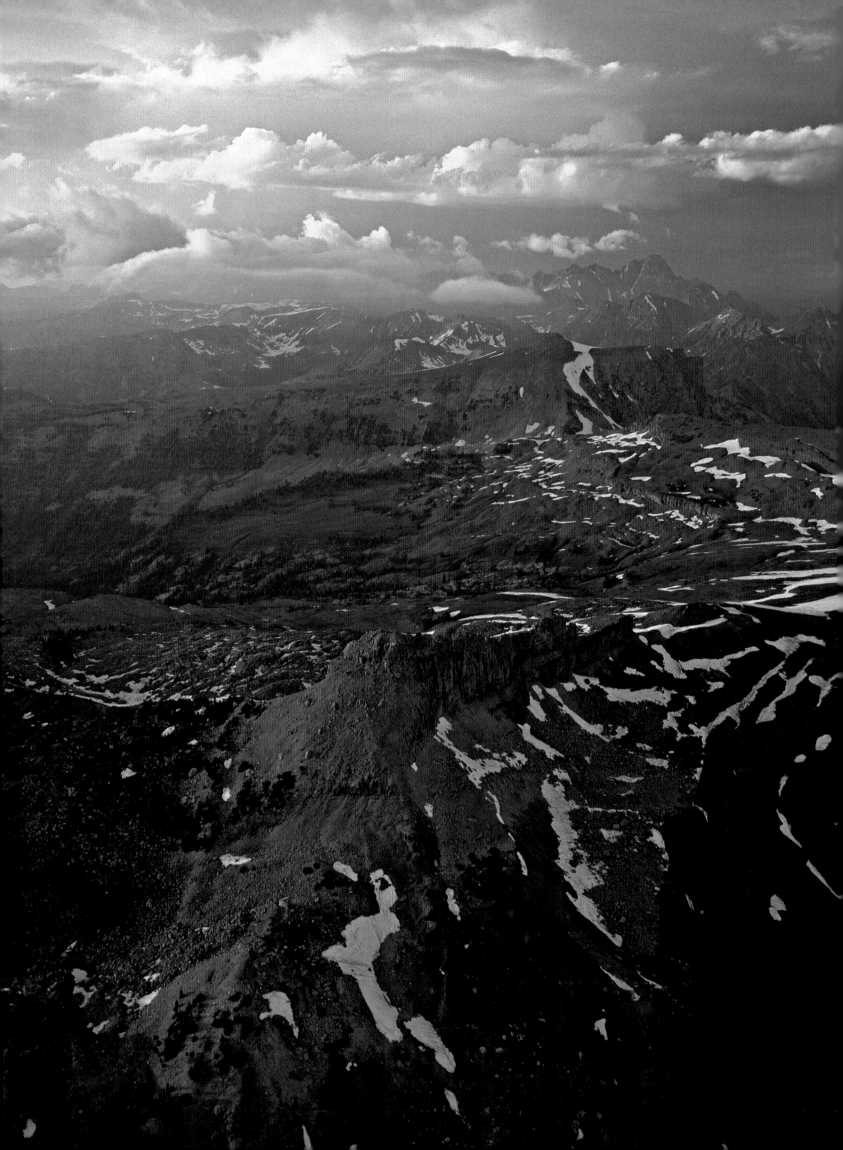

Left: Layered rocks in Granite Basin are visible as cliffs and ledges below the highest peaks of the Teton Range. Half a billion years ago, sedimentary layers like the Flathead Sandstone and the Bighorn Dolomite were deposited here on top of the much older Mount Owen Granite that makes up Grand Teton itself.

Right: In 1959, a gigantic block of rock and rubble broke loose from the now barren upper ridge, crashing into the Madison River northwest of the Teton Mountains. The toe of the debris came to rest against the opposite canyon wall, damming the river and instantly creating Earthquake Lake. A road has since been built across the landslide debris.

Grand Teton above the Alaska Basin, Wyoming.

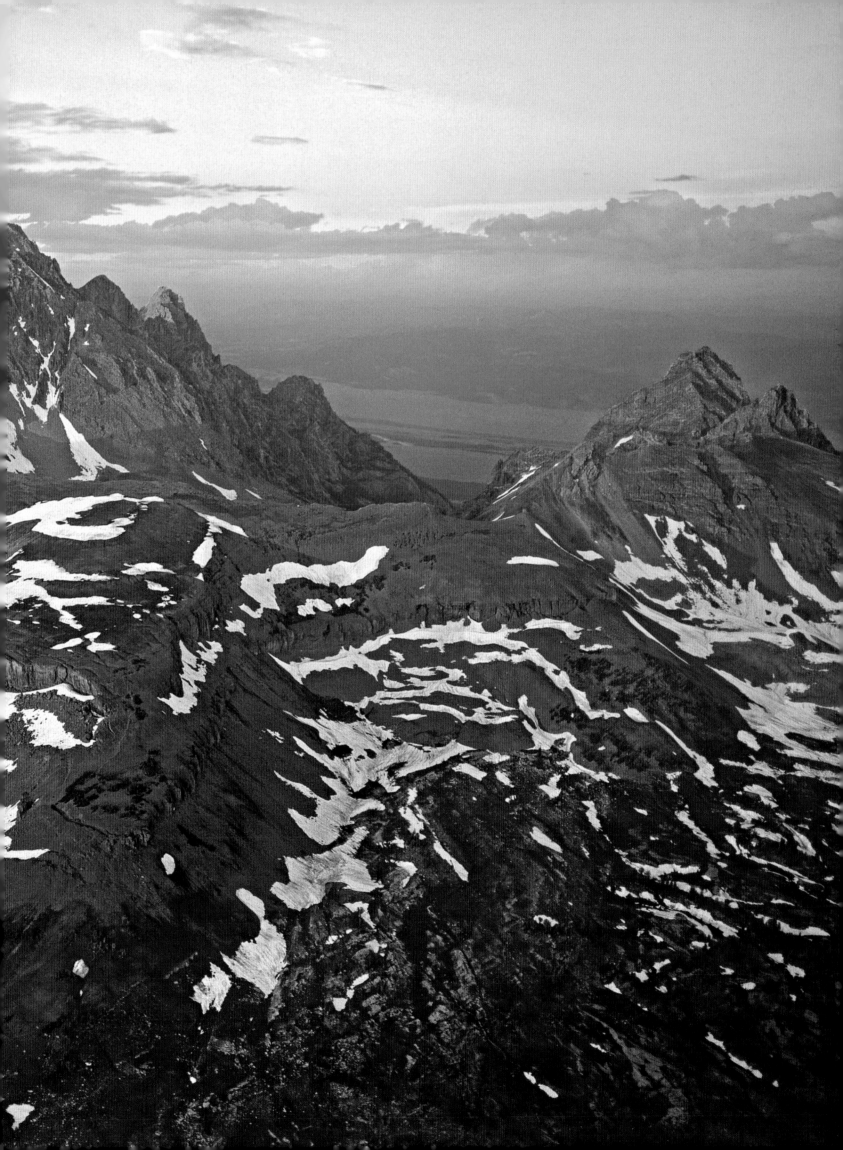

Let's turn to another vertically oriented force called isostasy. This idea explains how some mountains, like blocks of wood on a pond, bob up in a landscape. Clarence Dutton was the nineteenth-century geologist who first suggested the geologic implications of rock buoyancy. Here's an experiment: Float a block of wood in water. Once it quits sloshing around, mark the waterline. Then take it out and shave a few inches off the dry top. The wood is now lighter so that the line rides higher when you put the block back in the water. In exactly the same fashion, continents will ride higher on the mantle if erosion carves off the top few miles of rock. That's isostasy in action. Let's consider three places where this process has played an important role in shaping a landscape.

Carroll Glacier lies in the west arm of Alaska's Glacier Bay National Park. Carroll and all others in Glacier Bay were once quite large—on average, 3,000 feet thick. The world's climate has warmed since the 1850s, and glaciers around the globe are now retreating. The total volume of ice within Glacier Bay has shrunk by 720 cubic miles during the last 150 years. The walls visible above Carroll Glacier today have been ice-free for only a few decades. What happens when glaciers disappear so suddenly? Isostasy! When the weight of all that ice is removed, the land springs back up like our bobbing block of wood.

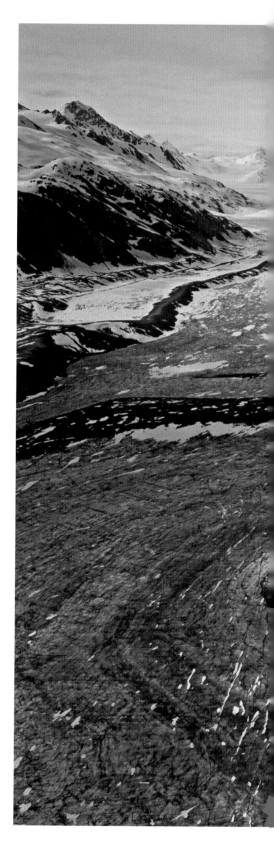

Carroll Glacier in Alaska's Glacier Bay National Park slithers down from the snowy Takhinsha Mountains at the rate of two or three feet a day. The glacier's surface is lined with squiggly brown moraines, each a mobile snake of boulders and dirt. As vast quantities of rock are removed from this landscape, it rebounds upward. Additionally, most glaciers in this region have dramatically shrunk, noticeably accelerating the rate of uplift.

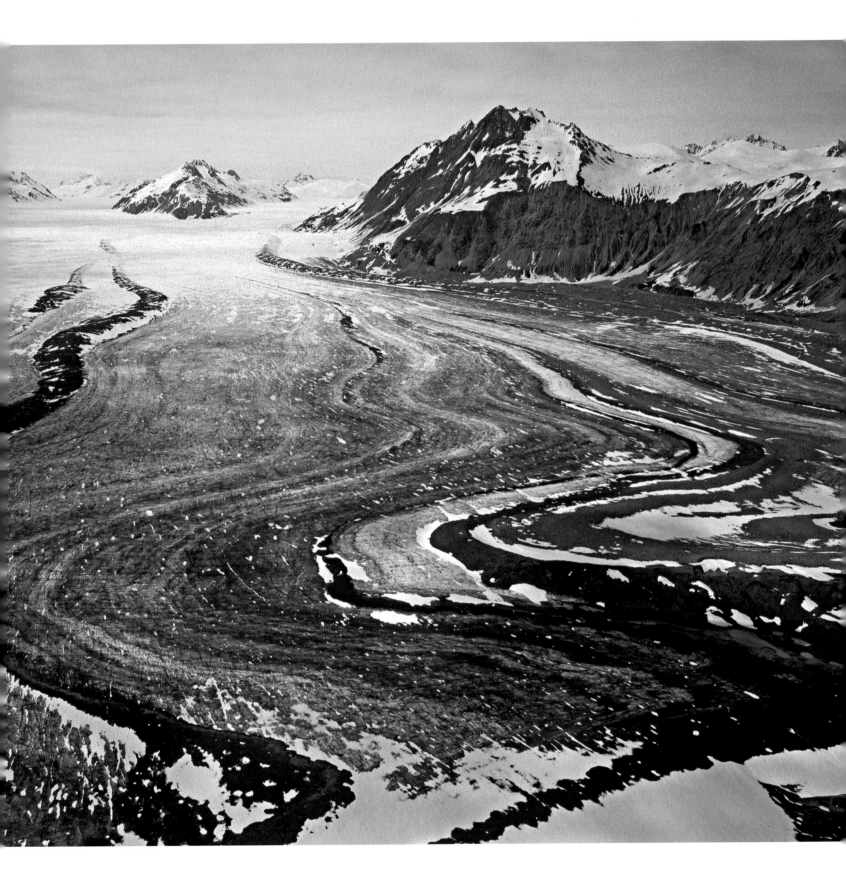

Bartlett Cove at the mouth of Glacier Bay is rising one and a half inches a year. The cove's shoreline is ten feet lower now than it was in 1879 when the first American adventurer paddled into Glacier Bay. Ten feet in little more than a century—that's 3/1,000 of an inch every day! Landscapes rarely rise so fast. But other factors are also operating at the same time.

Glaciers are tearing down the Fairweather Range before our very eyes; as a result, the mountains themselves are lighter. Isostasy steps in again, and up go the mountains. In addition, Glacier Bay happens to sit between two major fault zones where tectonic stresses have propelled Mount Fairweather 15,300 feet above the waters of Glacier Bay. These three factors—glacial retreat, mountain erosion, and tectonic pressure—have all contributed to the dramatic rise of land surfaces here.

Fairweather Range, Glacier Bay National Park, Alaska.

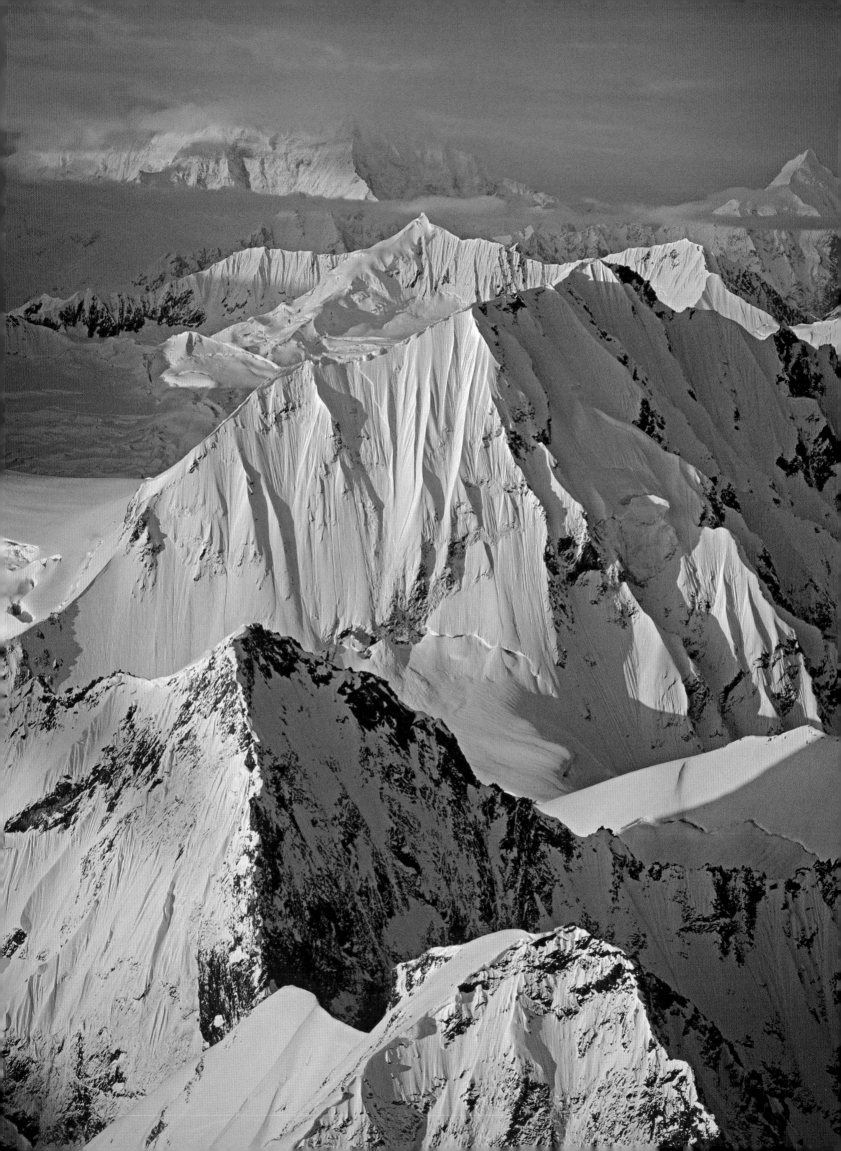

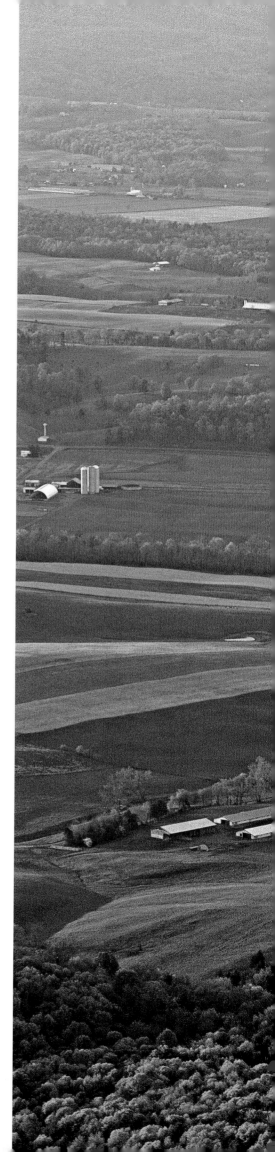

Isostasy has affected not only parts of Alaska but also portions of the eastern United States. In their prime the Appalachians were steep and rugged, standing many thousands of feet higher than they do today. The roots of the Appalachians extend like a ship's keel almost forty miles down into the mantle, much deeper than typically undisturbed continental crust. This deep root was in balance with the great height of the mountains above sea level.

Eventually the mountain-building forces that had given birth to the Appalachians ground to a halt. Wind and rain have taken their toll, lowering the once lofty peaks and softening the razor-sharp ridge lines, clipping a couple of inches off the top of the mountains every thousand years. This may seem slow, but given more than a quarter billion years, erosion should long ago have beveled the Appalachians back to sea level. So why do these mountains still stand? Isostasy! Like that bobbing block of wood, the deep root of the Appalachians is lighter than the mantle on which it floats, so it keeps rising back toward the surface as erosion slowly chews away the mountain peaks.

Shenandoah Valley, seen here near Bridgewater, Virginia, is part of the Valley and Ridge district of the Appalachian Province. This entire region has slowly risen, responding isostatically to erosion of the Appalachian chain.

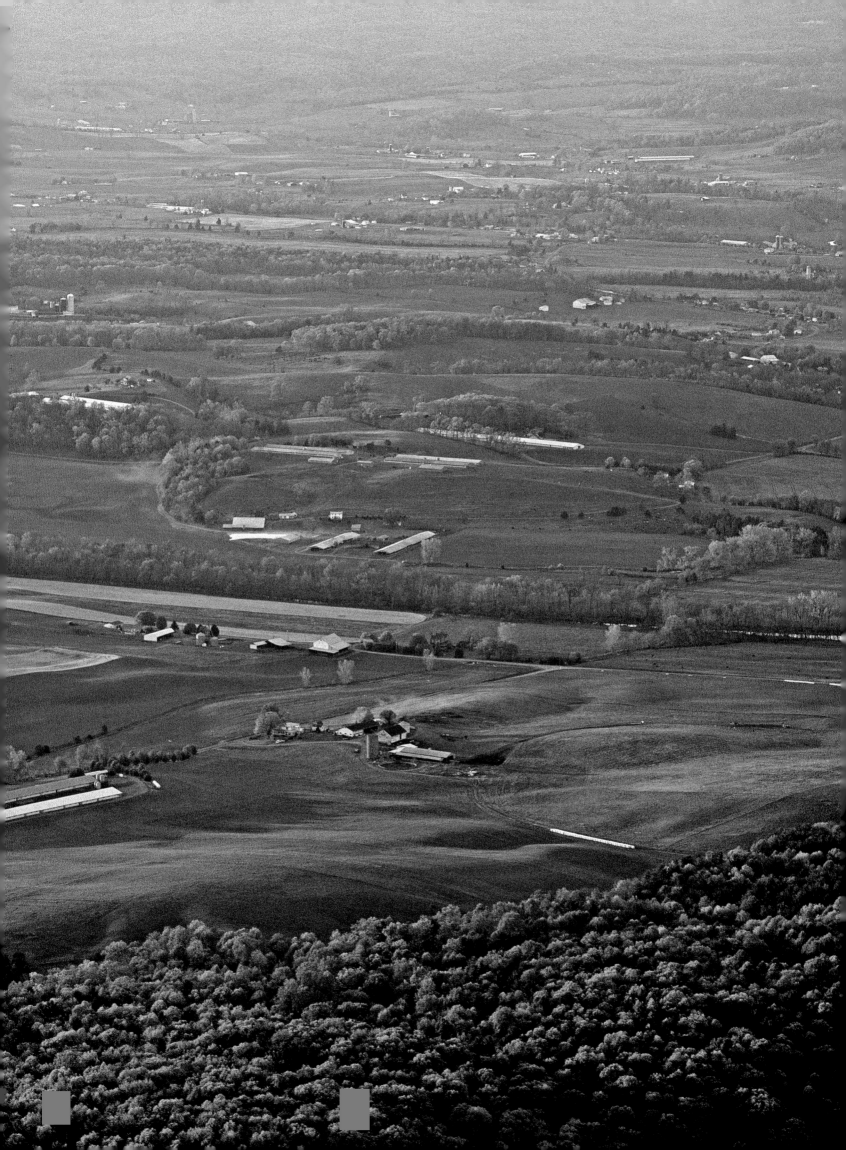

From the Appalachians, let's go west again to the Pacific Province of California to find a third and final example of a landscape modified by isostasy. At 14,496 feet, Mount Whitney is currently the highest point in both the Sierra Nevada and in the entire lower 48 states. One hundred and fifty million years ago, magma was first injected into chambers miles below the surface of what would become California. Over the next 65 million years, all of these underground cauldrons, called batholiths, cooled and froze into granite.

Be careful not to confuse the initial intrusion of Sierran granite with later uplift of the mountains. This entire landscape was much lower when the magma was introduced; it has only recently been so dramatically elevated. What triggered the uplift? Some geologists reason that the batholiths were lighter than the mantle and acted like balloons too light to remain deep within the earth. Inflated at depth with new granite, the Sierra Nevada range could have risen because of isostasy. Other geologists have speculated that Sierran sediment was shed west into California's Great Valley in such prodigious quantities that the mountains were catapulted upward as if they were on the light end of a teeter-totter. Perhaps both of these mechanisms have helped hoist the Sierra Nevada so high into the sky.

We've all made the mistake of thinking that mountains are eternal and unchanging. Nothing could be further from the truth. Peaks of the eastern Sierra are rocketing up at the dizzying rate of just over one-hundredth of an inch every year, a most impressive number in geologic terms. Today, the mountains are an inch and a half higher than when John Muir first walked through them in the 1870s. Muir stared in awe at these peaks, and wrote that here "rises the mighty Sierra, miles in height, reposing like a smooth, cumulus cloud in the sunny sky, and so gloriously colored, and so luminous, it seems to be not clothed with light, but wholly composed of it." After a decade of exploration, he rejoiced that the Sierra Nevada "seems to me above all others the Range of Light, the most divinely beautiful of all the mountain-chains I have seen."

Mount Whitney is only thirteen miles west of the town of Lone Pine, California, but it stands fully two miles higher, separated by the very active Sierra Nevada fault system that hides along the bottom of this picture. When Lone Pine was struck by the great earthquake of 1872, vertical movement along the fault instantly threw the mountains another thirteen feet higher relative to the town. Thirteen feet in a heartbeat!

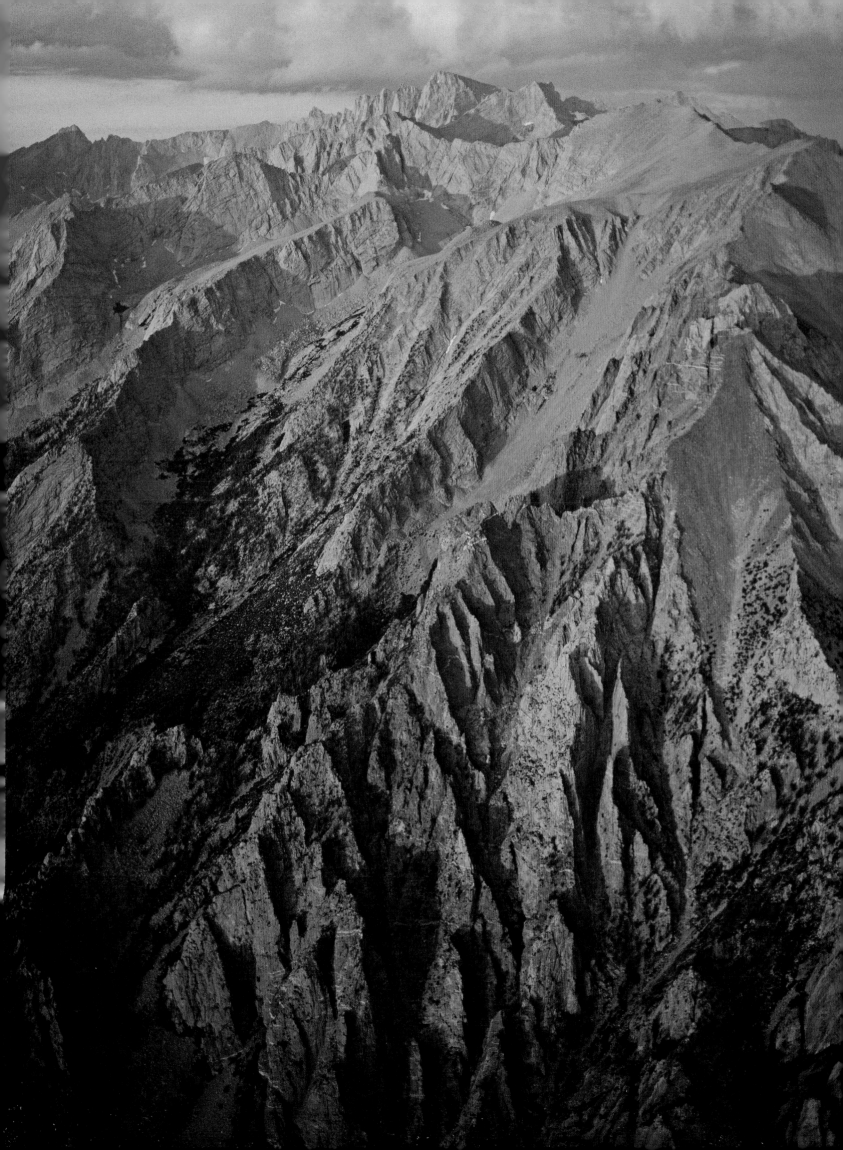

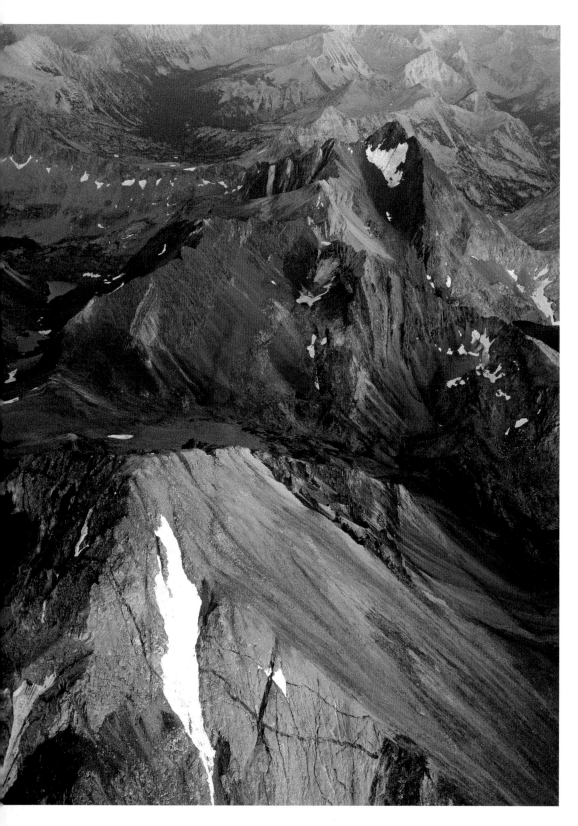

Left: Granitic terrain of the Sierra Nevada above Big Pine, California.

Right: Sierra Nevada near Mount Stanford, California.

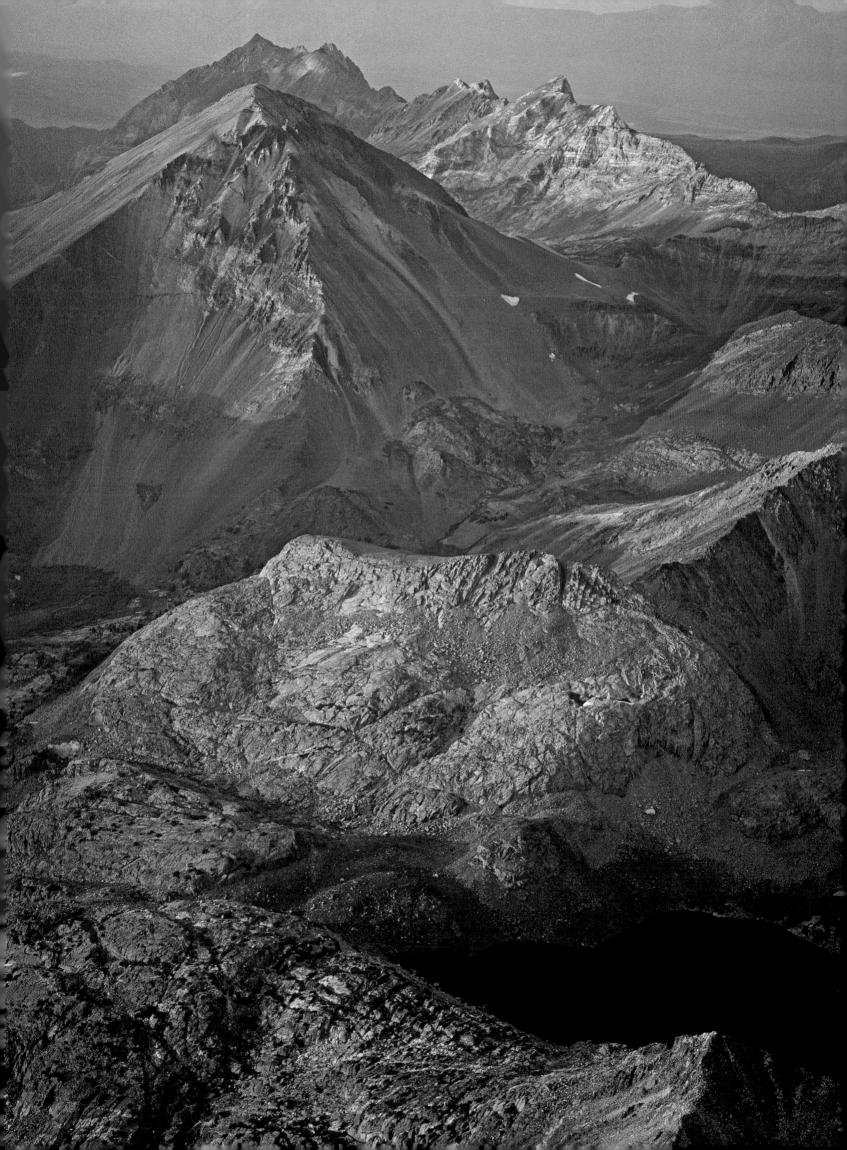

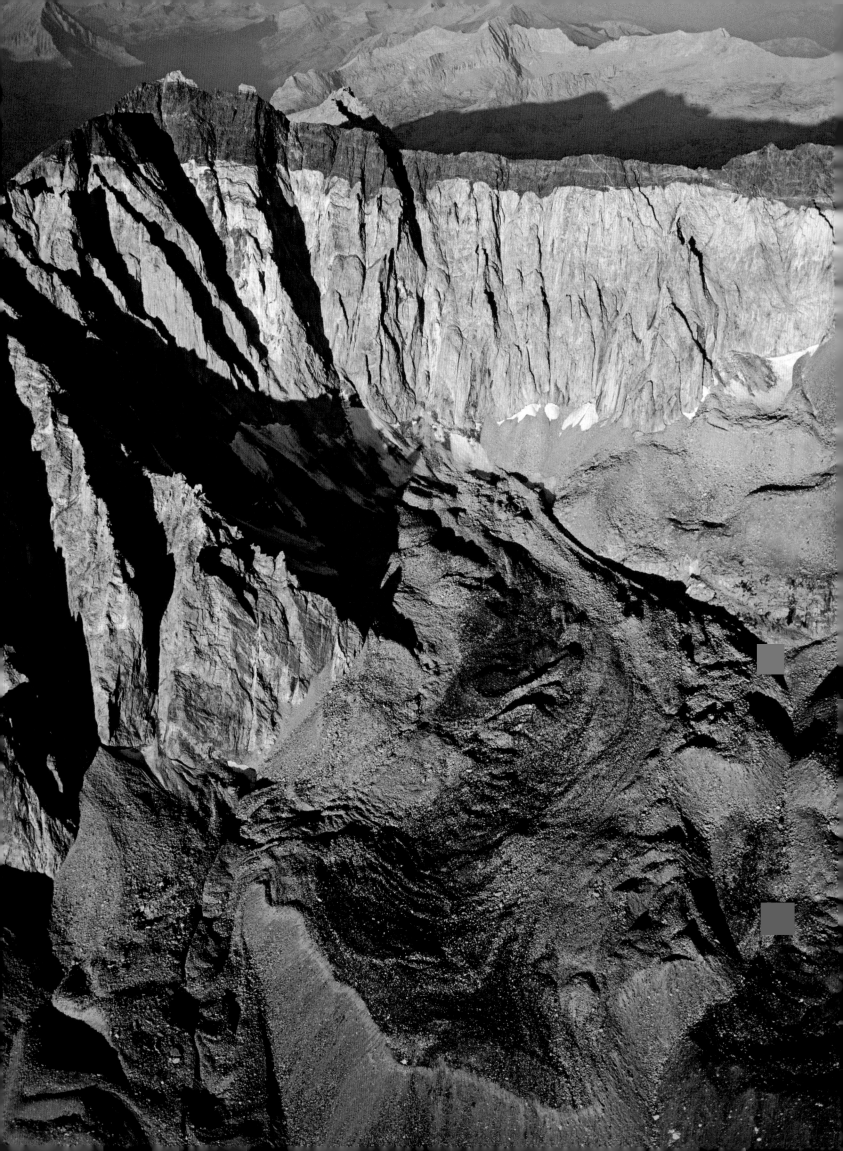

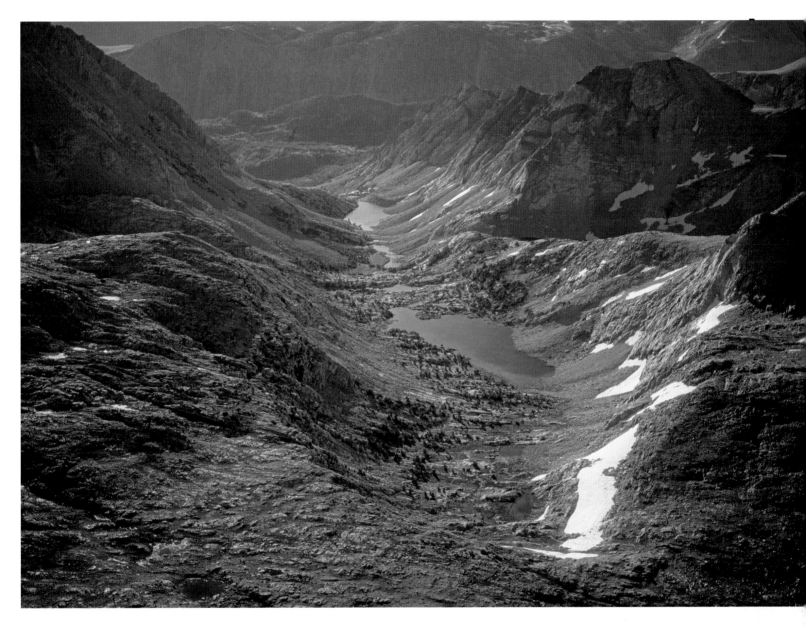

Above: The Sierra Nevada range was heavily glaciated. Ice scratched out U-shaped valleys and left divots that would later be filled in as alpine tarns.

Left: This cliff within California's Sierra Nevada near Independence tells the tale of molten rock flowing into a deeply buried chamber 85 million years ago. Silica-rich magma was injected into dark metamorphic rock and froze to become light-colored granite. The horizontal black-on-white contact between the granite and the chamber's roof is now clearly preserved at the top of the cliff. A sinuous rock glacier in the lower half of the picture ebbs downhill under the influence of gravity.

*Mount Patterson, straddling the
California-Nevada border near
Bridgeport, is the high point of the
Sweetwater Mountains, an outlier
of the Sierra Nevada.*

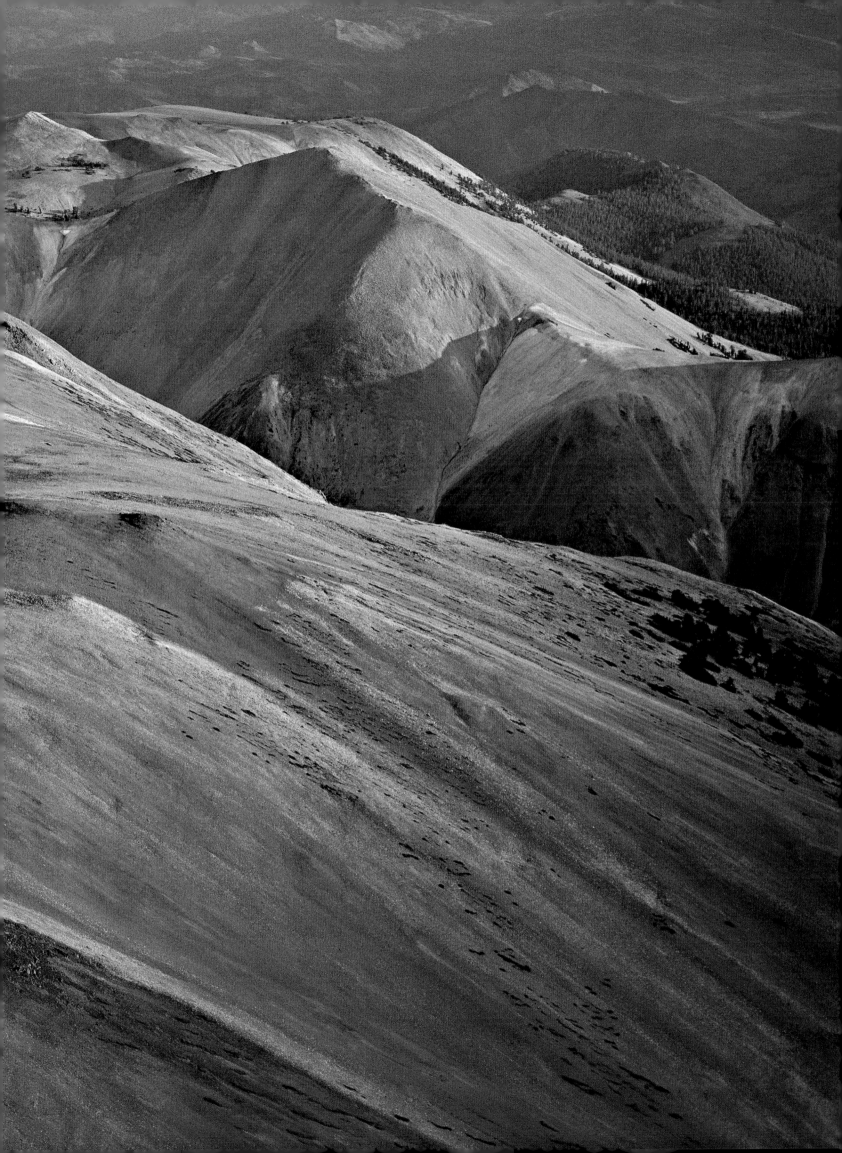

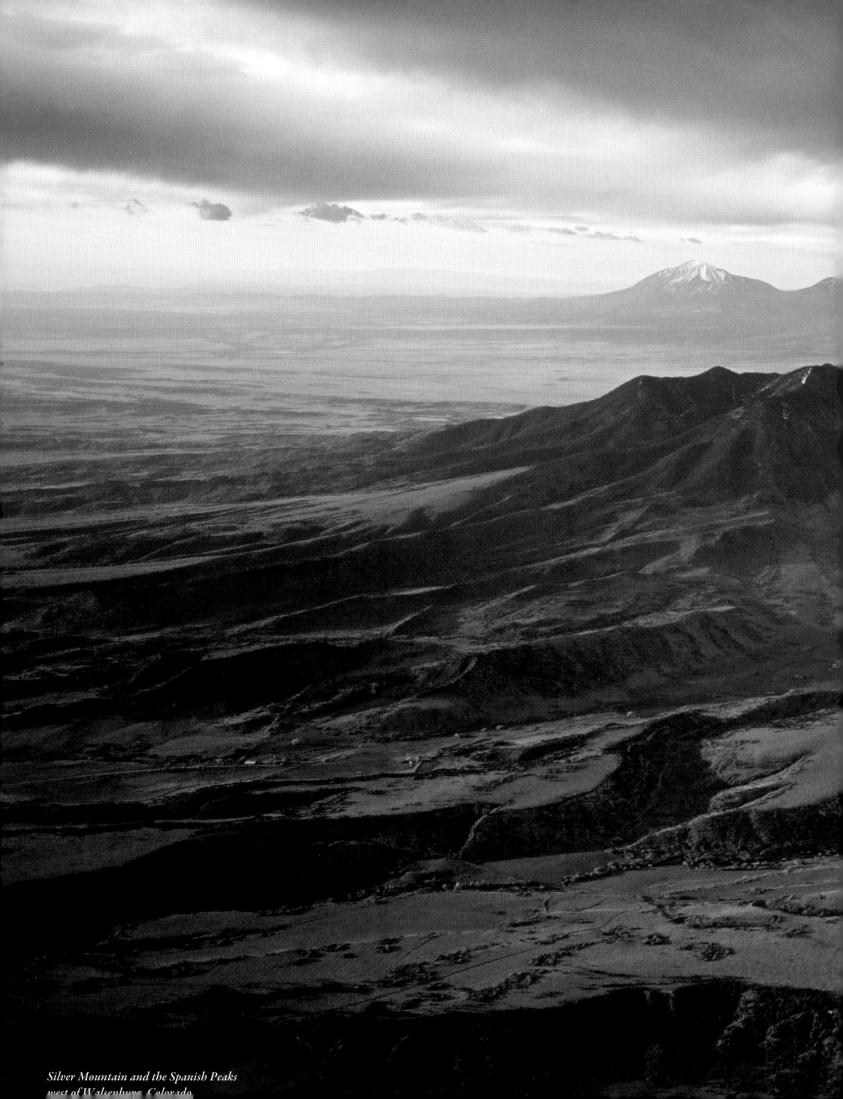

Silver Mountain and the Spanish Peaks
west of Walsenburg, Colorado

MOUNTAINS PAST AND FUTURE

Plate tectonics theory has ushered in a new consciousness of the earth's age. How much time are we talking about? Lots. It takes time to deposit sediments, time to bury layers so deep that they turn into stone, time for magma to ooze up through the crust, time to metamorphose sandstone to quartzite, and time to heave this whole crazy-quilt package back to the surface. It takes time to build mountains and still more time to tear them down and start all over again.

Can you relate to numbers? Our world was created four and a half billion years ago. The earth's most primitive life forms are thought to have appeared just in time to celebrate its first billion-year birthday. More sophisticated animals like trilobites evolved a little more than 500 million years ago. Dinosaurs lumbered around the earth 100 million years ago. But what do these millions and billions mean? Analogies, though sometimes awkward, can help put the numbers into perspective. "If the age of the earth is shrunk to a single year, then all of human history fits neatly into the last seventeen minutes of New Year's Eve." Or, "if the earth's age is compared to the distance to the moon, then Columbus discovered the New World only 146 feet ago."

I prefer to think of geologic time as a seamless continuum of events. Something happened a long time ago, and then another thing happened, and then another, and another. And another. There was time enough for an infinity of sand grains to blow across the desert and turn into sandstone. Time enough to cycle from sand through stone to mountains and then back to sand again. Who cares how much time? What matters is that the earth's history has in the past and continues now to unfold in a slow rolling cadence.

Mountains, we've learned, are cast from many molds. They stick up, bulge up, billow up, they blow up. They have life spans that bridge birth by tectonic turmoil and slow death at the hands of erosion. If mountains aren't eternal, then it's fair to ask how long will they be with us. We can look to the heavens for an answer. There is good evidence that the planet Mars once burned with internal fires capable of driving a process similar to plate tectonics on earth. Satellites and the Martian Rover have documented great mountains and water-carved canyons on the red planet,

features that point to a once active planetary interior. When fresh, these features would have been without blemish. But all surfaces on Mars are now equally pocked by a constant shower of meteors. If mountain-building on the red planet was still active, older surfaces would be more pocked than fresh young ones.

The even distribution of impact craters suggests an end of Martian mountain-building sometime in the distant past. That planet's tectonic fireworks have sputtered and died. Could mountains ever cease to grow on earth? Absolutely. Sooner or later, the earth's interior will lose its uranium and other fissionable materials; eventually its residual heat will escape into space. When the core cools, plate tectonics on earth will be over. A sad thought, but it will be many hundreds of millions of years before this comes to pass.

In the meantime, we have mountains. Our lives are graced by peaks and pinnacles, ridges and ramparts. To be alive on a living earth is to partake in the ongoing and evolving parade of geologic history. As we have seen, the details of that history are beautifully recorded on tablets of stone. To observe those details, to listen to the stories that mountains tell, is to be more fully engaged with the world in which we live.

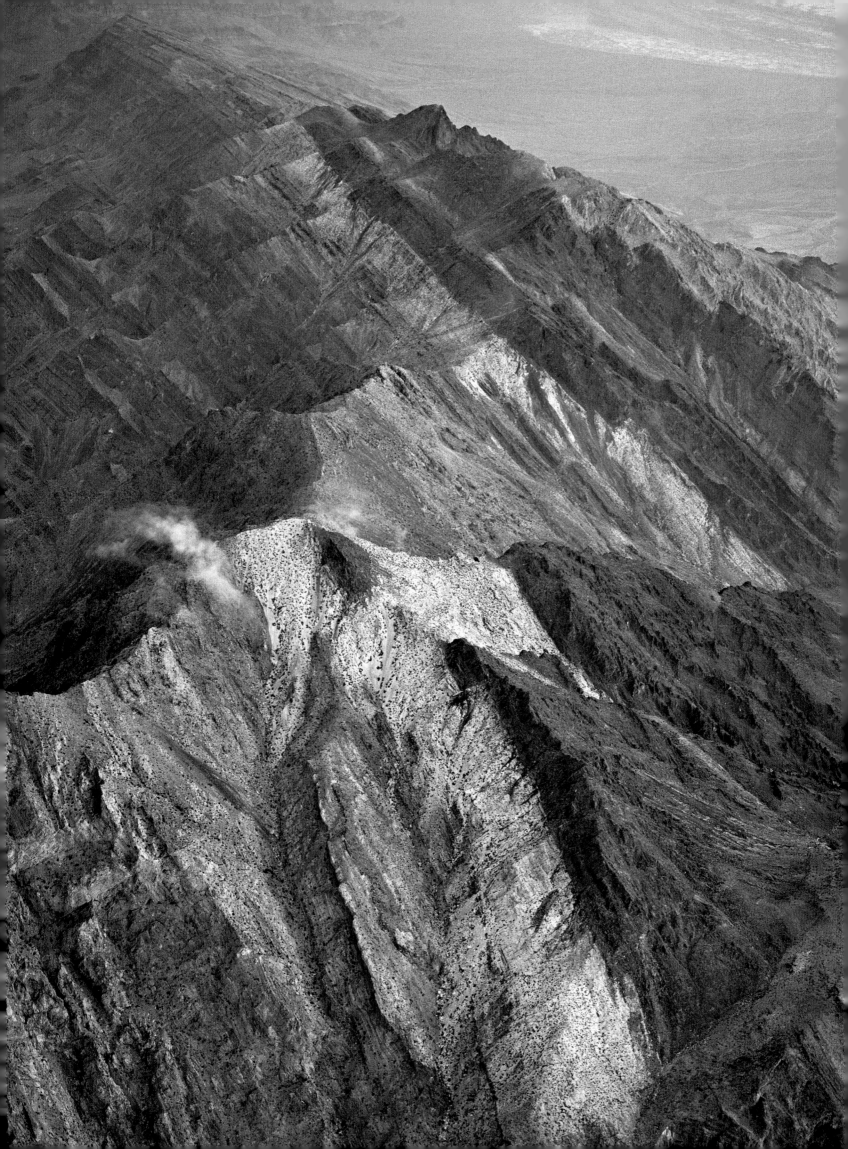

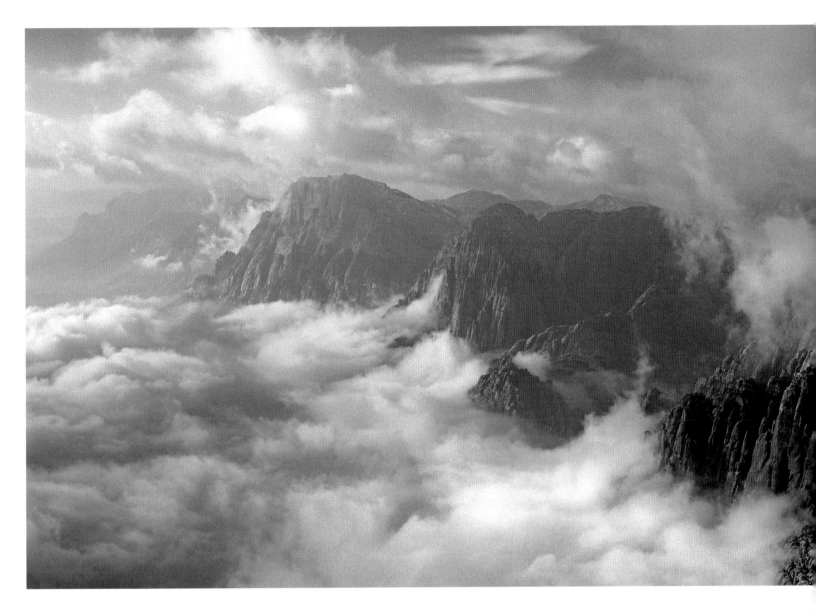

Above: The cliffs of Red Rock Canyon tower over the Mojave Desert near Las Vegas, Nevada. In a normal world, younger rocks would overlie older ones. But here, limestone of the older Bonanza King Formation has been thrust over the younger Aztec Sandstone along the Keystone Fault, turning time upside down.

Left: Mountain-building is alive and well in the western United States. At Bat Mountain near Death Valley Junction in eastern California, tilted layers of the white Eureka Quartzite lie beneath the black Ely Springs Dolomite; both were deposited about 460 million years ago. The rocks have been tipped up as the Basin and Range Province actively continues to stretch and thin.

The Panamint Dunes nestle against the lower reaches of Death Valley's Hunter Mountain—a study in contrasts of geologic time. To the right are the half-billion-year-old sedimentary rocks that lie below Panamint Butte. To the left, Hunter Mountain itself is composed of a granite-like rock called quartz monzonite that was injected into place about 150 million years ago. The dunes are a modern-day phenomenon, changing from one day to the next, true children of the moment.

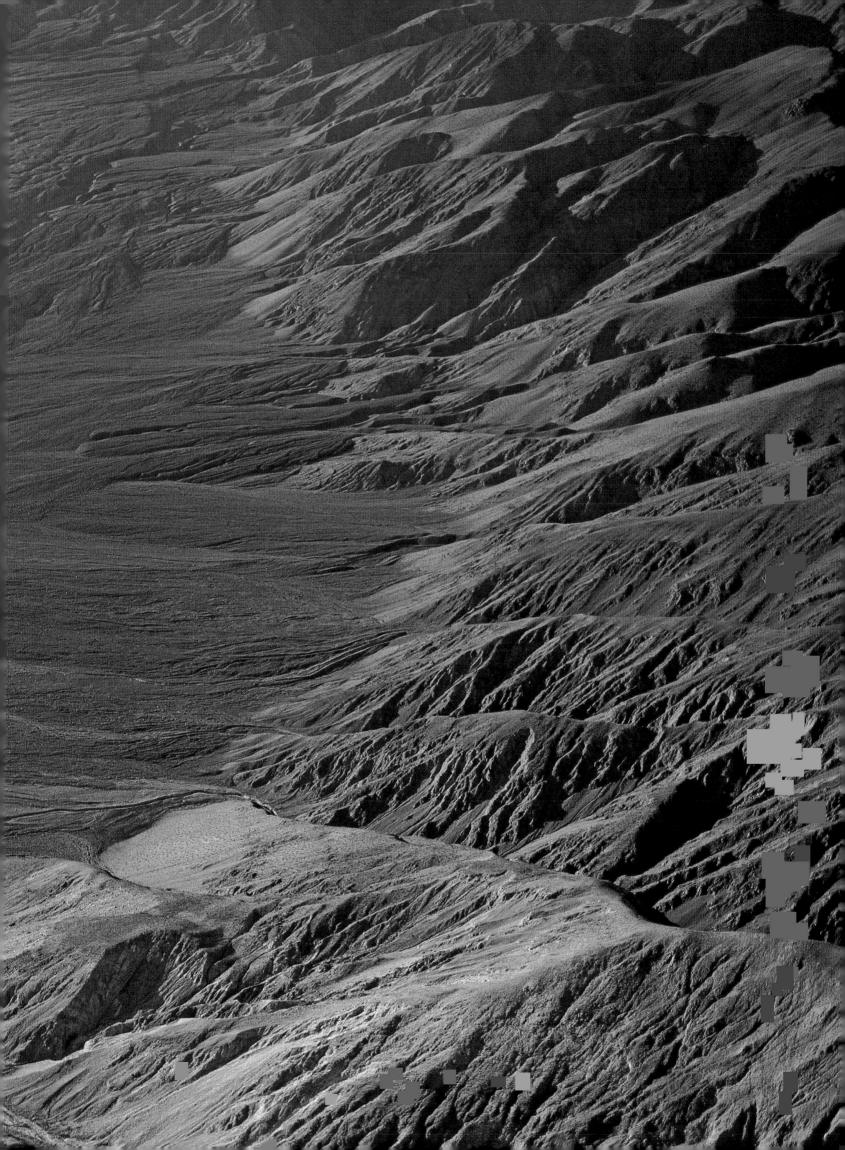

Nopah Range near Shoshone, California.

Photo Locations

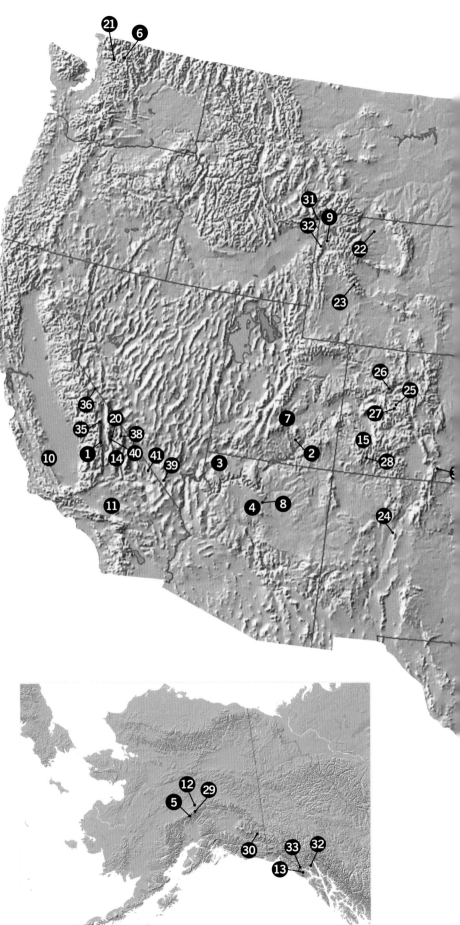

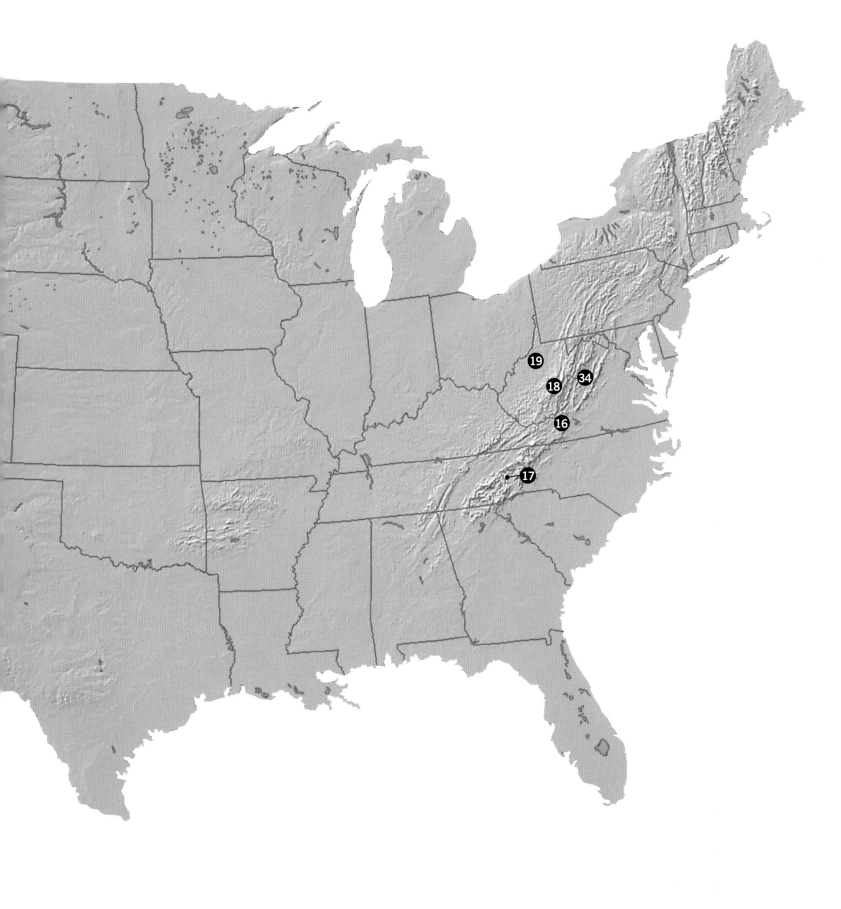

Glossary

Alluvial fan—*sediment deposited in a fan shape at the foot of a slope*

Bajada—*coalescent alluvial fans along the base of a mountain*

Basalt—*fine-grained igneous rock composed of dense iron-rich minerals like silicates and feldspar*

Basement rock—*oldest rocks in a region, often igneous or metamorphic*

Batholith—*large mass of igneous rock injected at depth*

Cirque—*bowl-shaped basin carved at the head of a glacier*

Core—*center of the earth below a depth of 1,800 miles, composed chiefly of iron and nickel*

Crust—*thin outermost solid layer of the earth, divided into oceanic and continental portions*

Erosion—*physical removal of rock fragments by wind, water, or ice*

Fault—*break in rock along which movement has occurred*

Glacier—*body of compacted ice that moves downhill under the influence of gravity*

Gneiss—*coarse-grained metamorphic rock with rough parallel alignment of its minerals*

Granite—*coarse-grained igneous rock formed by the underground intrusion of magma*

Igneous—*any rock formed from the crystallization of magma*

Isostasy—*process by which materials of differing density seek a preferred altitude above or below sea level under the influence of gravity*

Limestone—*sedimentary rock composed of calcium carbonate*

Magma—*molten rock*

Mantle—*outer 1,800 miles of the earth, consisting of dense iron- and silica-rich minerals*

Marble—*metamorphic rock formed by gently heating and squeezing limestone*

Metamorphic– *any rock formed under a variety of pressures and temperatures that cause crystals, without melting, to realign into a new suite of minerals*

Mineral—*natural inorganic crystalline solid with a definite chemical composition*

Normal fault—*fracture along which one piece of rock moves vertically relative to another*

Plate—*distinctive piece of the earth's outer surface, composed of thin dense oceanic crust, thicker lighter continental crust, or both*

Plateau—*regional highland*

Plate tectonics—*theory describing the earth's crust as an interactive set of crustal plates*

Playa—*flat floor of an enclosed basin*

Province—*large region characterized by similar geologic history*

Quartzite—*metamorphic rock formed from quartz-cemented sand grains*

Sandstone—*sedimentary rock composed of quartz, feldspar or other grains with diameters from 0.0625 to 2 millimeters*

Schist—*metamorphic rock with marked alignment of its minerals*

Sediment—*any material transported and deposited by physical agents such as wind, water, or ice*

Sedimentary—*rock composed of cemented sediments*

Siltstone—*fine-grained sedimentary rock composed of grains with diameters from 0.0039 to 0.062 millimeters*

Spreading center—*crest of mid-ocean ridge from which sea floor crust moves away in both directions*

Subduction—*sinking of ocean floor beneath an opposing plate*

Suspect terrane—*fault-bounded region with a distinctive geologic history*

Tarn—*small lake in a glacial cirque*

Tectonics—*study of the large-scale deformation of the earth*

Thrust fault—*fracture along which one rock is pushed up over another*

Volcano—*igneous landform created by the eruption of magma at the earth's surface*

Weathering—*disintegration of rock into soil or sediment at the earth's surface*

Selected Bibliography

Condie, Kent C., 1997, *Plate Tectonics and Crustal Evolution*; Butterworth-Heinemann, Oxford.

Oreskes, Naomi (ed), 2001, *Plate Tectonics*; Westview, Cambridge, MA.

Redfern, Ron, 2001, *Origins*; University of Oklahoma Press, Norman.

Shelton, John, 1966, *Geology Illustrated*; W.H. Freeman and Company, San Francisco.

Tarbuck, Edward J. and Lutgens, Frederick K., 2005, *Earth*; 8th Edition, Pearson/Prentice Hall, Upper Saddle River, NJ.

Wegener, Alfred, 1924, *The Origin of Continents and Oceans*, translated by J.W. Evans; E.P. Dutton and Company, New York.

Acknowledgments

Aerial photography is a wonderful lonely endeavor. I've spent thousands of hours in the cockpit of my fifty-year-old Cessna. It's the rare soul who can stomach more than a few hours aloft with me; admittedly the plane is not always straight and level. Most are dissuaded by the searing boredom of waiting on the ground at Duckwater for the right light, petting the broken-down airport dog in Rawlins while rain drums on the hangar roof, or walking three miles into Smithers for yet another hamburger while a repaired cylinder is being shipped from Kansas. But these inconveniences are the price of admission to a lofty window that opens onto a beautiful world.

Over the years, a few good friends have tagged along: Chris Condit introduced me to flying thirty years ago. Roger Henderson and Ed Peacock held the wheel while I hung out the window, cameras flapping in the breeze. Jene Vredevoogd, with his good humor and great resourcefulness, was remarkably helpful during months spent above the mountains and ice of Alaska.

It was an honor to meet two giants of geology while working on this book. Dave Love and I flew for days over Wyoming as he reminisced about sixty years of studying a landscape he deeply cherished. Dave finished his Ph.D. at Yale just as John Shelton started there in 1938. John changed the way geologists look at the world when he published *Geology Illustrated* in 1966, with its gorgeous aerial photographs. While discussing this book, John imparted an inspiring enthusiasm as we swapped stories about discovering the earth from above.

Dr. Chuck Barnes of Northern Arizona University was kind enough to review the manuscript and suggest course corrections to keep me in mid-channel. After thirty-one years of friendship, Chuck continues to be a guiding star in my geologic sky. Stu Waldman and Elizabeth Mann at Mikaya Press have been perfect editors, demanding yet understanding. Lesley Ehlers's design and illustrations have helped shed light on ideas that are difficult to portray in words alone.

The American Geological Institute has been generous in its support of this work. The Institute encourages a broad appreciation for the geologic sciences. I am particularly indebted to Ray Thomasson, past president of the board, and to Marcus Milling, Chris Keane, Ann Benbow, and Abi Howe at the Institute's Washington, D.C. office.

And as always, it is Rose Houk who stands smiling behind every picture I've taken, every word I've written.

Index